Watercolor in Bloom

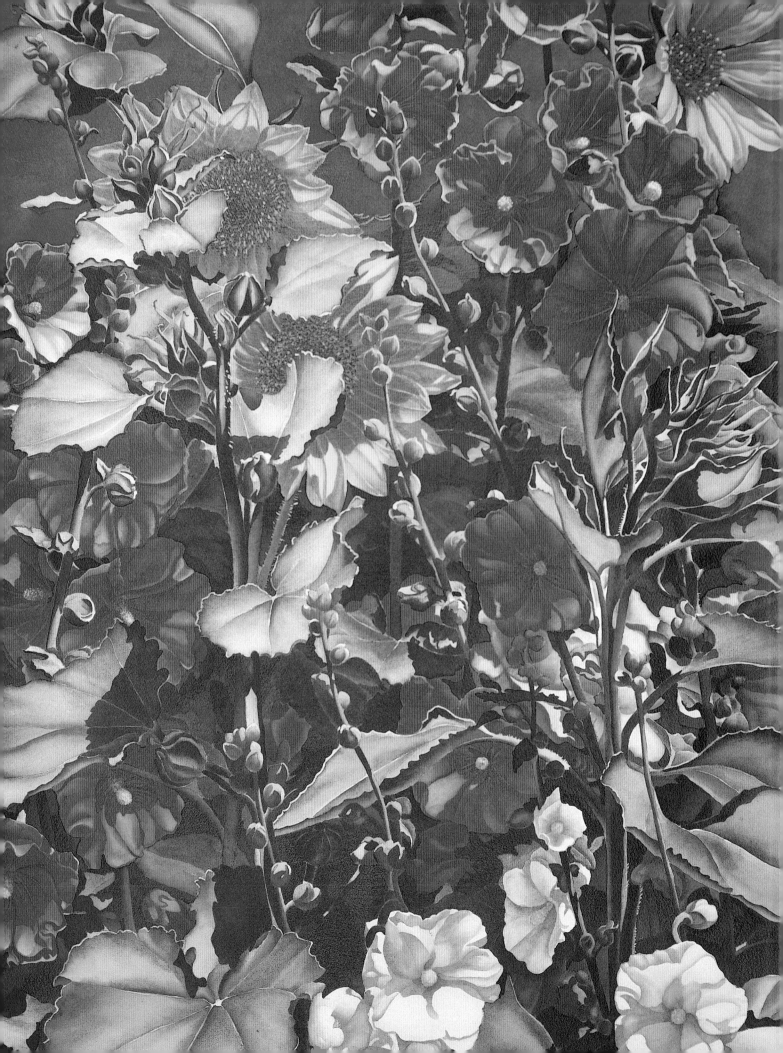

WATERCOLOR
in Bloom

painting spring
summer garden

Mary Backer

NORTH LIGHT BOOKS
CINCINNATI, OHIO
www.artistsnetwork.com

Watercolor in Bloom: Painting the Spring and Summer Garden. Copyright © 2007 by Mary Weinstein Backer. Manufactured in China. All rights reserved. No part of this book may be reproduced in any form or by any electronic or mechanical means including information storage and retrieval systems without permission in writing from the publisher, except by a reviewer who may quote brief passages in a review. Published by North Light Books, an imprint of F+W Publications, Inc., 4700 East Galbraith Road, Cincinnati, Ohio, 45236. (800) 289-0963. First Edition.

Other fine North Light Books are available from your local bookstore, art supply store or direct from the publisher.

11 10 09 08 07 5 4 3 2 1

DISTRIBUTED IN CANADA BY FRASER DIRECT
100 Armstrong Avenue
Georgetown, ON, Canada L7G 5S4
Tel: (905) 877-4411

DISTRIBUTED IN THE U.K. AND EUROPE BY DAVID & CHARLES
Brunel House, Newton Abbot, Devon, TQ12 4PU, England
Tel: (+44) 1626 323200, Fax: (+44) 1626 323319
Email: postmaster@davidandcharles.co.uk

DISTRIBUTED IN AUSTRALIA BY CAPRICORN LINK
P.O. Box 704, S. Windsor NSW, 2756 Australia
Tel: (02) 4577-3555

Library of Congress Cataloging in Publication Data
Backer, Mary Weinstein
 Watercolor in bloom : painting the spring and summer garden / Mary Weinstein Backer. -- 1st ed.
 p. cm.
 Includes bibliographical references and index.
 ISBN-13: 978-1-58180-834-6 (hardcover : alk. paper)
 ISBN-10: 1-58180-834-8 (hardcover : alk. paper)
 1. Gardens in art. 2. Seasons in art. 3. Watercolor painting--Technique. I. Title.
ND2237.B33 2007
743.7--dc22 2006029044

Edited by Vanessa Lyman
Designed by Wendy Dunning
Interior layout by Lisa Holstein
Production coordinated by Jennifer Wagner

About the Author

As a child Mary was never without a pencil or crayon and paper to draw on. "I always doodled, and coloring books were a passion of mine." A California native, Mary grew up in the Pasadena area and now resides with her husband Pat in Banning, California. After her high school graduation, she married and raised two children. Although she enrolled in the Famous Artist's Course, studying commercial art, the demand of raising a family prevented her from continuing, and she put aside her dreams of becoming an artist. Her dreams finally came true following her retirement from the real estate business in the early 1980s when she enrolled in the Laguna Beach School of Art, Laguna Beach, California. Her teacher, Roger Armstrong, encouraged her to enter the National Watercolor Society annual competition. Her work was accepted into the exhibit, and she received the honor of Signature Member. With a good start in the fundamentals, she went on to study with Scott Moore, Linda Stevens Moyer and Robert E. Wood.

Mary was always in love with watercolor. "It was watercolor from the start." Her work represents her personal way of seeing, point of view, interpretation and unique expression. "I find inspiration in everything that surrounds me. I strive to give the viewer a heightened awareness, to stimulate the richness of their surroundings. People often miss the beauty around them. I like to help them see it more fully through my paintings."

Mary Backer's awards and honors are many; her work is included in museum, corporate and private collections, and she has been published in leading art publications including *Splash 1*, *Splash 9* and *The Best of Flower Painting* (North Light Books); *Painting Composition, Easy Solutions: Color Mixing*, and *Art of the American West* (Rockport Publishers); and *Watercolor* magazine.

She is a signature member of the National Watercolor Society, a past president of Watercolor West and an Artist member of the California Art Club.

previous page:

SUNSATION | *Watercolor on Arches 1114-lb. (2339gsm) rough-pressed* | *40"× 60" (102cm × 152cm)* | *Private Collection*

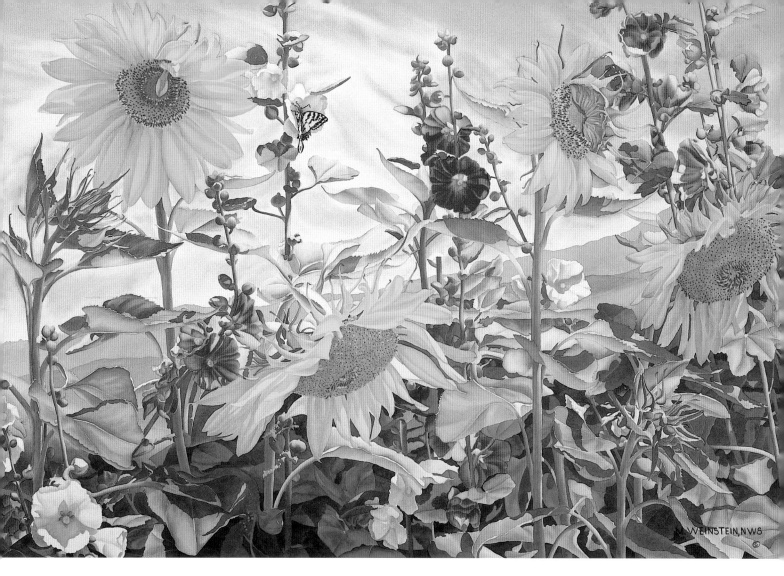

Acknowledgements

I would like to acknowledge the following people:

My late husband, Sigmund Weinstein, who encouraged me to begin painting and gave me the necessary support and breathing room for me to accomplish my goals.

My teachers, Scott Moore, Linda Stevens Moyer and the late Robert E. Wood. Their work was my inspiration, and it was a privilege to learn from them the process of painting in watercolor.

Pat Backer, my loving and caring husband; a talented photographer who shares his life with me and believes in me and my work.

My editors, Vanessa Lyman and Mona Michael, who helped me get started and guided me through the process of creating this book.

Dedication

To my grandmother, Mary Ann Broderick, an Irish lass and world class gardener who inspired me in the joy and beauty of nature.

KALEIDOSCOPE | *Watercolor Arches 300-lb. (640gsm) rough-pressed* | *41"× 29" (104cm × 74cm)*

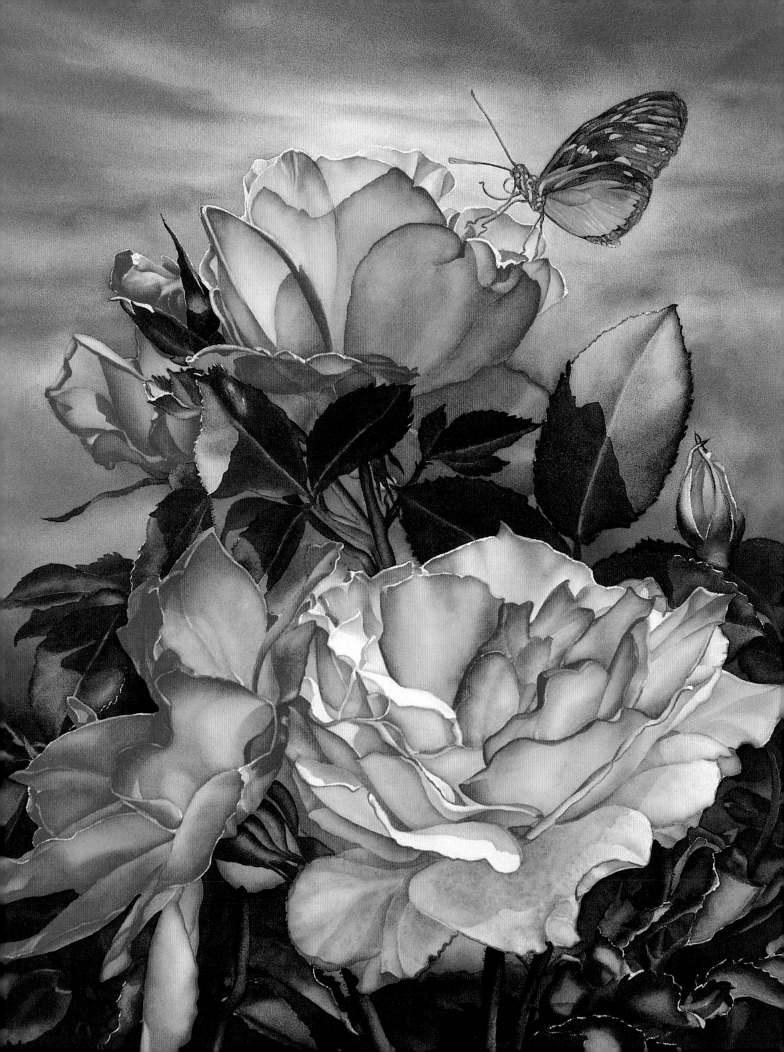

AMBROSIA | *Watercolor on Arches 550-lb. (1155gsm) rough-pressed* | *41"× 29" (104cm × 74cm)* | *Private Collection*

Table of Contents

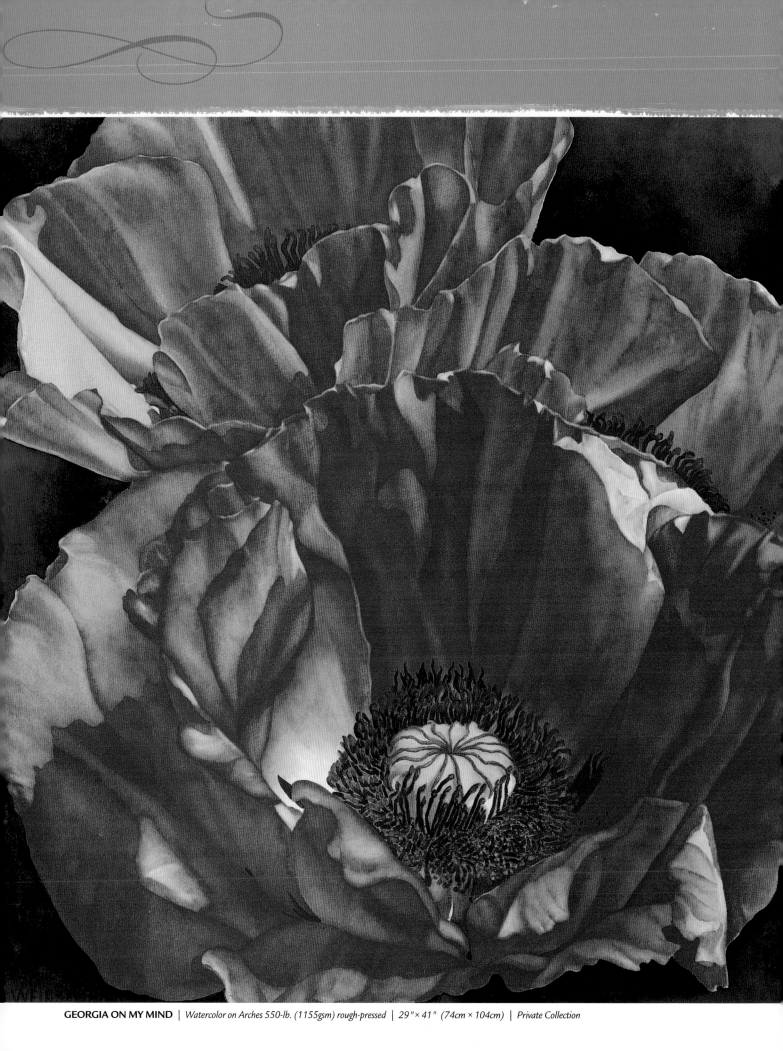

GEORGIA ON MY MIND | *Watercolor on Arches 550-lb. (1155gsm) rough-pressed* | *29" × 41" (74cm × 104cm)* | *Private Collection*

Introduction

The title of this book aptly describes its intent. I'm well aware that there are as many approaches to painting as there are painters. This book is meant to be a guide, rather than a set of hard and fast rules. My primary purpose in creating this book is to explain, by demonstration or illustration, many of the details that present problems to the beginning and intermediate artist when painting flowers.

As you learn more techniques to help you paint your subject, don't lose sight of learning to apply that knowledge artistically. An expertly rendered image for all its carefully applied technique, cannot outshine a painting born from a sensitive and original approach to the principles of art—composition, color, values, edges.

This book is filled with careful step-by-step descriptions of the painting procedure. I suggest that you do some of the steps as exercises and then, as you gain confidence, apply the principles to your own work. Don't confine yourself to copying the instructions too literally. This book goes beyond the content of painting or what colors "go together." It's intended to help you achieve the results you desire. The process works for me, and I hope it will do the same for you.

Still—in a way—nobody sees a flower—really—it is so small—we haven't time—and to see takes time, like to have a friend takes time.

—Georgia O'Keefe

In writing this book, I'm inviting your to share my way of seeing. I'll guide you through the entire painting process, from selecting your subject to the finished work. If you have the desire, you can learn to paint flowers in watercolor. Do not be discouraged if your first attempts are not "masterpieces." After all, if we created a great painting each and every time, what would be left to accomplish? Take it one step at a time, one inch at a time, one brushstroke at a time, and you will realize your dreams.

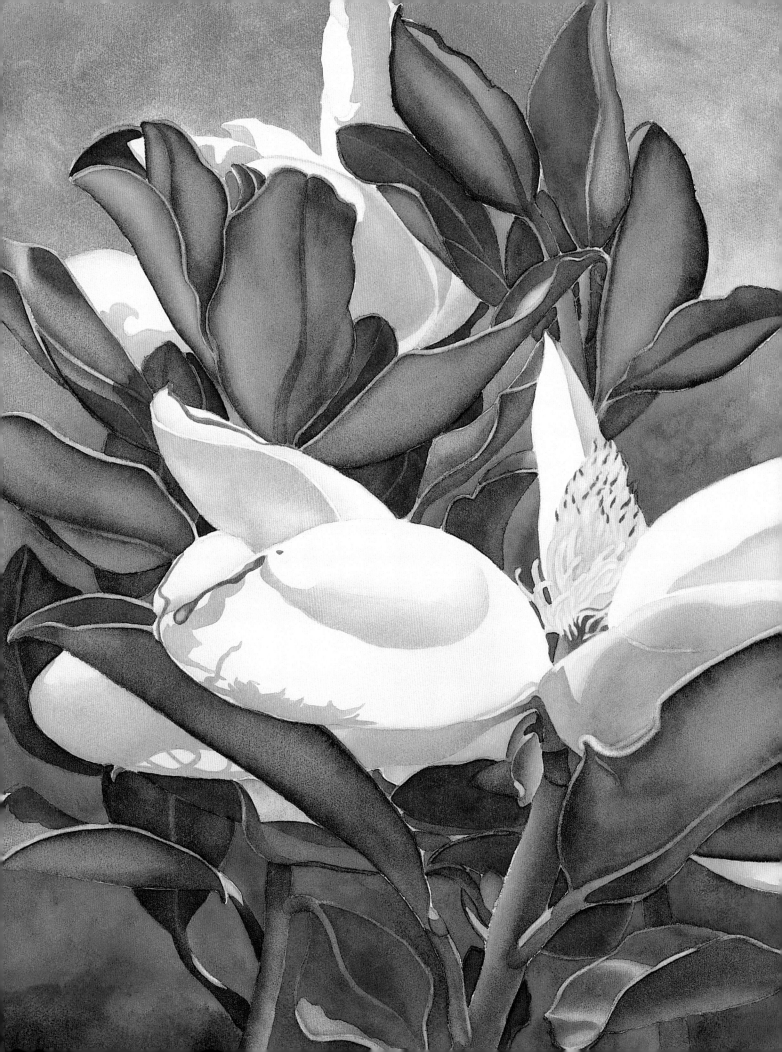

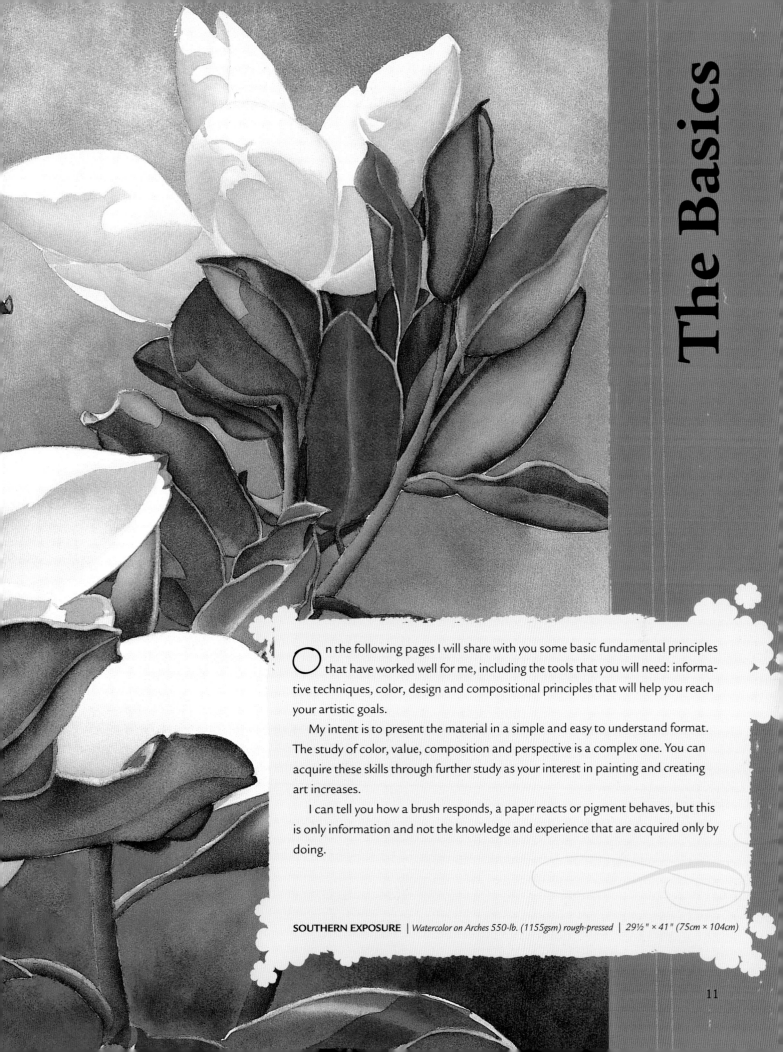

On the following pages I will share with you some basic fundamental principles that have worked well for me, including the tools that you will need: informative techniques, color, design and compositional principles that will help you reach your artistic goals.

My intent is to present the material in a simple and easy to understand format. The study of color, value, composition and perspective is a complex one. You can acquire these skills through further study as your interest in painting and creating art increases.

I can tell you how a brush responds, a paper reacts or pigment behaves, but this is only information and not the knowledge and experience that are acquired only by doing.

SOUTHERN EXPOSURE | *Watercolor on Arches 550-lb. (1155gsm) rough-pressed* | *29½" × 41" (75cm × 104cm)*

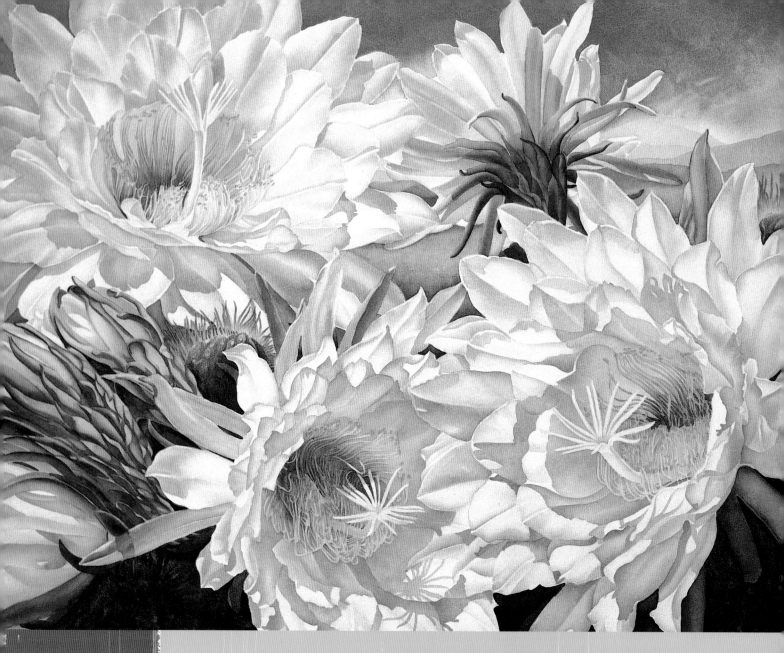

1 *The* Tools

IF YOU'VE ALREADY PAINTED IN WATERCOLOR, you know about such things as paint, paper, brushes, etc., so consider this a quick review. For the artist new to watercolor, this section will be an introduction to the materials artists use. You will not need to purchase large amounts of expensive materials and supplies. Rather, be selective. A good painter can create with just the three primary colors: red, yellow and blue. It's better to spend a little more on one excellent brush than to acquire many inferior brushes. The following pages will help you make informed choices about the materials and supplies that will work best for you. I'll be suggesting things I like to use myself. If you work with quality products from the beginning, you'll be rewarded in your finished painting.

CACTACEOUS | *Watercolor on Arches 550-lb. (1155gsm) rough-pressed* | *29" × 41" (74cm × 104cm)* | *Collection Brand Library and Art Galleries*

Your Work Space

Choosing a good work space is important. A work space doesn't need to be large, but it should be arranged efficiently. I have book cases along one wall that store my slide files and miscellaneous art related matter; my stereo sits on top, tuned to my favorite jazz station. To the right of my easel is a taboret storing paints and other painting supplies. Alongside the taboret sits my painting surface—a large, flat, laminate tabletop easel.

While natural lighting—especially north light—is wonderful, you can supplement. I use an Ott-Lite to illuminate my work area. Above are spot lights.

Keep your area as easy-to-clean as possible. The flooring in my studio is a laminated wood surface that's easy to wipe up. A convenient water supply is also essential.

A few framed paintings hang on the walls, but most of my framed artwork and frames, along with a flat file that stores paper and finished work, is kept elsewhere.

My Workspace

Taking the Time

My day begins with exercise, and then it's into the studio by 10:00 A.M. to begin the day's challenge. My day ends around 5:00 P.M. I make it a point never to paint when I'm tired. There's always tomorrow, and a fresh body and mind are more receptive to creativity.

13

The Basics

Every painting starts with the basic materials. Get to know the tools that build your paintings.

BRUSHES

There's no magic brush that will paint a masterpiece, but a good brush *can* go a long way towards make the painting process easier. Of all the things you'll need for painting in watercolor, brushes are the most important. Buy the best brushes that you can afford. The brushes that I use are the Winsor Newton Series 7 Kolinsky sable rounds in sizes 4, 6, 8, 10. If you can only afford one good sable brush, I suggest buying a no. 8 round. It's my workhorse.

The sables are for watercolor only. *Don't* use them for acrylic; acrylic paint can ruin brushes with natural fibers. For acrylic, synthetic brushes are the best, and there are many good brands on the market. The synthetic brushes are inexpensive, so they're a good choice for the beginner. They don't hold as much paint as a sable, but they are nevertheless good, all-around brushes. I have found the Robert Simmons brand to be very good. I use sizes 4, 6, 8, 10 rounds, plus a 1-inch (25mm) and a 3-inch (75mm) flat. If you take care of your brushes, they'll give you many years of service. Keep a container of brush cleaner nearby to clean your brushes after the day's use. Liquid soap can be used to clean the brushes you use for acrylics. Never let paint dry on the brushes (acrylic hardens like cement), and store your brushes flat when they're wet.

PAPER

Watercolor papers are made of different materials and come in various weights. Cotton rag papers are made from the longest cotton fibers and considered to be of the highest quality, lasting up to a hundred years. A good cotton paper can handle heavy erasing and reworking. Cellulose or wood pulp papers are of a lesser quality, and a high acid content will destroy the paper over time.

The weight of a paper is gauged by the weight of the whole ream. I'd suggest paper of 140-lb. (300gsm) to 300-lb. (640gsm). The 300-lb. (640gsm) is my choice; it stands up to a lot of punishment. Buy a sheet of each and try it out.

Watercolor paper is sold in several surfaces: rough-pressed, cold-pressed and hot-pressed. The majority of my paintings are painted on Arches rough-pressed paper. I like how the paint sinks down into the "dimples" of the rough surface, and allows me to stack many layers of pigment. Paper is a personal thing, so try various brands until you find one you like.

Some papers contain a good deal of sizing and tend to fight the paint. If you have this problem, it can be minimized by stretching the paper on a board, taping or stapling around the borders and sponging down before painting. (This is also helpful in reducing buckling in lighter papers.) You can submerge your sheet of paper in the bathtub and sponge the sizing off. I stretched my paper until I attended a workshop taught by Robert E. Wood. He informed the students that he no longer stretched his paper. Bob would hold the paper on his board with bull dog clips and move them around the painting as he worked. Not only was this more maneuverable, but it was also less time consuming. I've been using this technique every since.

There is a right and wrong side to watercolor paper. The right side is where you can read the watermark. I like to paint on this side, but many artists use both sides of the paper without any problem.

Brushes

Palettes

PALETTES

You have many choices for a water-color palette. Choose one that has a cover with paint reservoirs and a large mixing area. My choice is the Robert E. Wood palette because it has a cover that prevents the paints from drying out between painting sessions. A small wet sponge inside the closed palette also helps keep the paint from drying out. For acrylic, I've found that divided plastic dinner plates work nicely. They're cheap, dis-posable and, by placing another plate on top, can keep the paint moist. Clean water is essential for paint-ing in watercolor, so keep two water containers, one with clean water and another for the dirty water. Any container will work, but I like bowls that are dishwasher safe, that way every once in a while they get a really good cleaning.

OTHER MATERIALS

A few other items you'll find useful:

- A fairly firm support for your watercolor paper, such as Masonite, plywood or Styrofoam. This should work fine in the beginning. My work surface is a large flat laminate table, and it has an adjustable tilt.

- Masking tape (drafting tape is best), thumb tacks, or bull dog clips.

- Erasers. The white Magic Rub is my favorite. Some artists like the kneaded rubber eraser, but this eraser contains oils and can cause problems in your painting. Avoid hard red erasers; they're too harsh for watercolor paper. In an emer-gency, an electric eraser can be a helpful tool.

Other Materials

- Tracing paper. I like the 36″ × 10″ (91cm × 25cm) size.

- Graphite transfer paper. For transferring your image to the watercolor paper.

- Black Pentel pen for transferring your image from tracing paper to watercolor paper.

- Graphite pencils. The softer graphite (4B and 6B) tend to smudge. The harder graphite can dig into the paper, leaving a mark that paint will gravitate towards. I usually use a no. 2 office pencil.

- Sketchbook. The sketchbook can contain drawing paper, or (as I prefer) tracing paper with a grid.

- Masking fluid. This product is designed to save the white of the paper. I don't use it much.

- Natural sponges or a large syn-thetic sponge. One large one for sponging the paper, and several small sizes for various other tasks.

- Craft knife or single-edged razor blade for making corrections.

- Small spray bottle for wetting paper and paint.

- Small bristle brush for lift-ing and soft-ening edges.

- Electric pencil sharpener.

- Cotton swabs.

- Box of tissue.

- Paper towels.

- Slide projector for slides. If you work from prints, an opaque pro-jector will be useful.

Paints

Acrylic and watercolor are considered watermedia because they can be thinned with water. Despite that, watercolor's medium isn't water; its medium is gum arabic. The medium for acrylic is a polymer emulsion, a fluid plastic. Water is used to thin the two to a brushable consistency. When thinned with water, watercolor and acrylic behave in a similar manner. It's after they're dry that the major difference becomes apparent. Dried watercolor can be dissolved again in water; acrylic cannot. Dried acrylic becomes a transparent, porous, flexible film on the painting surface. If no white paint is added to acrylic it is more transparent than "transparent" watercolor.

Acrylic has more color strength than watercolor and when used as a final glaze over watercolor adds "punch" to a painting.

WATERCOLOR

When painting in watercolor, I prefer professional quality tube paints, not the student grade. Although transparency is not my primary goal in a watercolor painting, I like to begin my underpaintings with the purest pigments.

The brand I use most often is Winsor & Newton. I also use Daniel Smith and Grumbacher. In acrylic, I use Golden, Winsor & Newton and Grumbacher. All are good products. The color choices are almost limitless, and I'm sure that you'll want to try them all; it's like being a kid in a candy store.

My palette is uncomplicated. The colors are divided into two categories: basic and full (unlimited) color palette. There are no formulas, no limited or restricted rules about which color belongs with which, and you can immediately begin to paint with the basic colors.

Some pigments will stain the paper and remain there. These are the

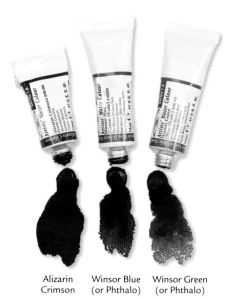

BASIC WATERCOLOR

Aureolin Yellow (Cobalt Yellow) Rose Madder Genuine Cobalt Blue Viridian Green

STAINING TRANSPARENT WATERCOLOR

Alizarin Crimson Winsor Blue (or Phthalo) Winsor Green (or Phthalo)

Watercolor Palette

strong transparent pigments: Alizarin Crimson, Winsor (or Phthalo) Blue and Winsor (or Phthalo) Green. The secret to using these pigments is to dilute them generously. Undiluted, they have enormous strength, making them a good choice for rich, transparent darks. A wonderful black is achieved from mixing Alizarin Crimson and Winsor (or Phthalo) Green.

My palette changes from painting to painting, depending upon the subject that I'm painting and the mood that I want to convey.

ACRYLIC

Using transparent acrylic allows you to glaze over previous layers without disturbing them and creating that dreaded "mud." You may make as many passes as you wish, because the dried layers below won't dissolve no matter how hard you scrub. Unlike watercolor, dried passages of acrylic cannot be removed. I wait until my watercolor painting is at a stage where I want to add more brilliant color, then I seal the watercolor "underpainting" and proceed with transparent acrylic.

Beating Acrylic's Drying Time

Mixing matte soft gel medium into your color and adding a drop of retarder will enable you to work the acrylic very much like your watercolors. One of the big problems in using acrylic is its fast drying time. Gel medium and retarder slow it down, and the matte finish will dry to a flat watercolor look. This allows a blending of the two mediums. In the finished work, it'll appear to be a watercolor painting.

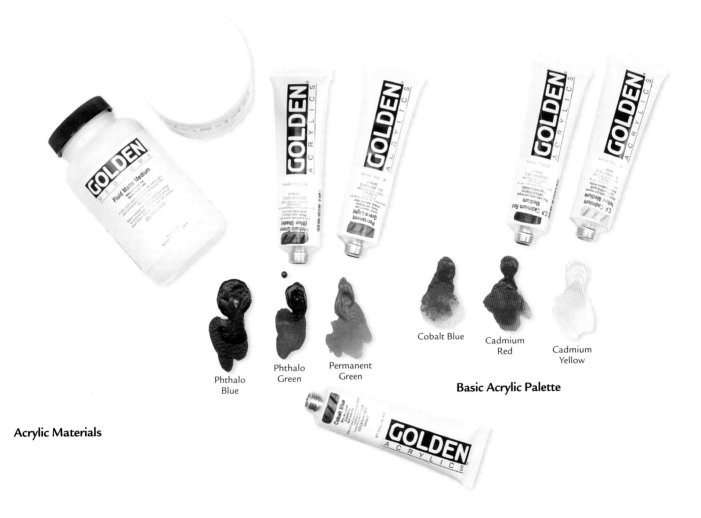

Phthalo
Blue

Phthalo
Green

Permanent
Green

Cobalt Blue

Cadmium
Red

Cadmium
Yellow

Basic Acrylic Palette

Acrylic Materials

Gathering Ideas With the Camera

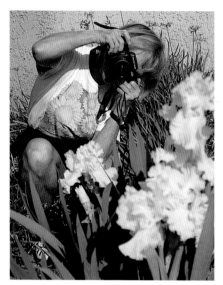

My use of photographs as part of the painting process began one winter after moving from the beach to the mountains. During that stormy first winter, it was almost impossible to get down the mountain, and my garden was hibernating. I began looking through slides from the previous summer; all kinds of ideas developed from what I saw. I spent the remainder of the winter season painting from enlargements that were made from the slides. The process of using photos to develop my paintings continues today.

The use of photographs by artists is a delicate subject and a matter for much discussion and debate. The fact that you use photographs is unimportant, but how you use them is very important indeed. When you use photographs, make certain that they're not using you. Use your photographs for data, but interpret the information in your own way. Express your own ideas in composition, color and treatment. If you are going to use photographs, take plenty of them. This will give you a better selection of material to choose from.

Artist at Work

No Shortcuts

Even though we're in the age of technology there are no shortcuts to creating quality art. Good art is the product of an artist's hard work and dedication to his or her craft. A painting is an artist's interpretation of a subject. The camera, projector and computer should be used as tools rather than as crutches.

Reference Shots
These are wonderful reference shots that I'll one day be able to paint.

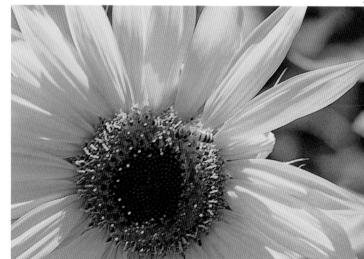

Working With Slides

When my slides get back from being processed, I can hardly wait to see if the paintings I visualized have been captured on film. I review the slides using a handheld viewer, discarding the unusable shots and placing the acceptable ones in plastic slide holders. The slides are catalogued according to subject or plant species and are stored in three-ring binders. When I'm ready to make a selection for a painting, the slides, still in holders, are placed on a light table for viewing. This is when I get excited because so many ideas are generated. As I pick out the images that I'd like to use, I slip them into another slide sheet so that I can view my selection as a whole. Some will be used, others not. I generally scan the accepted images into my computer, printing them out as 8″ × 10″ (20cm × 25cm) or 12″ × 14″ (30cm × 36cm). These prints are labeled and filed away until I'm ready to paint.

Three-Ring Binder

Camera and Film

Light Box and Slide Sheet

Begin Your Collection

Now is a good time for you to begin collecting a reference file with picture clippings from magazines, newspapers, catalogues, books and many other sources. Birds, animals, flowers, barns, landscapes and other subjects are likely to appear in your pictures.

Remember never to make an exact tracing or copy from this file. It's only for ideas and reference. This type of file contains copyright material, so avoid getting into serious trouble. For the artist, a photograph can provide only facts for his picture—never the picture itself.

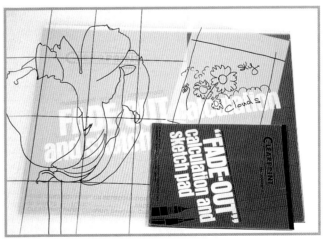

Tracing Material

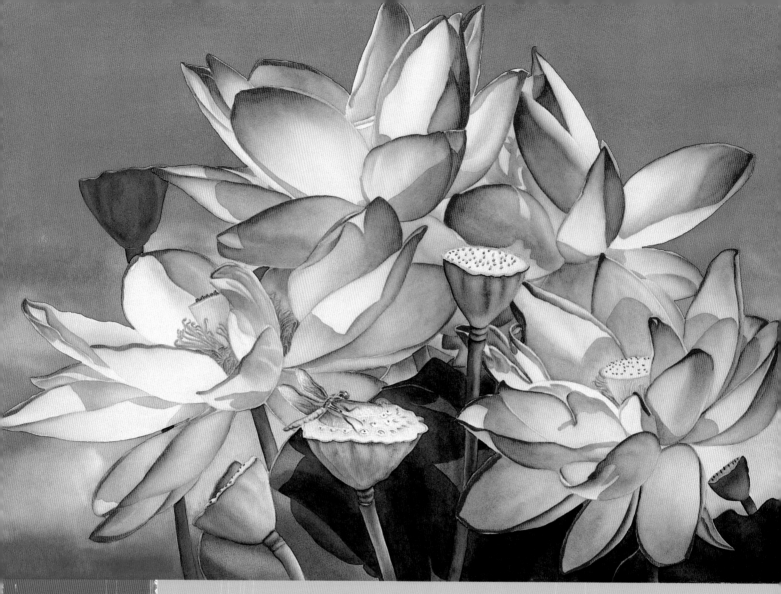

2 Composition *and Design*

COMPOSITION IS SIMPLY THE ARRANGEMENT OF SHAPES OR objects in your picture to produce a harmonious whole that is pleasing to your eye.

Basically, a picture is a series of relationships between objects and the space around them. It is the art of assembling the various elements you want in the picture and, through applying artistic judgment, placing them harmoniously within a given area to produce a perfect and completely unified picture.

In this chapter, you will learn to use the information you have gathered to design your painting from a sketch, drawing or photograph by arranging the shapes on tracing paper and using a grid to place your most important object correctly in the picture space. When you are satisfied with your idea, you will then learn to transfer the image to watercolor paper.

The objective of this chapter is to show you how to successfully arrange the elements of design, space and objects and how to give beauty to your paintings.

IKEBANA | *Watercolor on Arches 500-lb. (1050gsm) rough-pressed* | *29" × 41" (74cm × 104cm)*

Fundamental Principles

It's rare for nature to provide a ready-made composition with a completely satisfactory design. A good painting is usually a reorganization of the subject rather than a mirroring of nature's real arrangements. It's up to the artist to take these separate ingredients and orchestrate them into harmonious compositions. These design considerations can help you become a more competent picture builder:

- **Unity**. A painting benefits in its overall organization from a single, predominant design theme. You want to find the unifying theme that can organize the shapes within your painting and prevent them from being a chaotic gathering of unrelated bits and pieces. The choice of a major theme might be suggested by the subject matter, like color or shape.

- **Scale**. By controlling the variation in the size of shapes, you can create dramatic tension in your compositions. Establish a scale of large, middle-sized and small shapes that relate in some way.

- **Balance**. The most formal design is a composition with a symmetrical balance—one in which each form on one side of the page is balanced by a similar shape on the other side. Asymmetrical balance, however, is often used to produce more variety. A small shape on one side of a composition can balance a larger object nearer the center of the page on the other side. Such contrasts provide bolder statements of scale. Consider also the balance of weight, space, and warm and cool colors, softness and crispness, and texture as well as the size of shapes. Balance is an inclusive concept.

- **Rhythm**. Rhythm is the placement of elements in the composition so that the eye finds its way through the picture to the focal point. The correct use of rhythm in a composition will give your picture an actual sense of movement as well as harmony. Effective rhythm is accomplished by varying the size and position of the repeated elements. In establishing the point of emphasis, the composition, direction and arrangement of the design is all important.

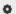

Organizing Shapes for Good Design
These bright cactus flowers are organized shapes that prevent the painting from being a gathering of unrelated bits and pieces. The varied sizes create dramatic tension. A bold statement of scale is achieved by contrasting the balance of the large shape to the left and the small shape to the right. The other shapes add variety. There is a balance of warm and cool colors, softness and crispness. The deep, cool background brings visual depth to the painting, pulling the cactus flower shapes forward.

ENCORE
Watercolor on Arches 550-lb. (1155gsm) rough-pressed
29" × 41" (74cm × 104cm)

21

Space Division

In your work as an artist, you need a practical procedure to create your composition. Since everything in art must be related and that harmony depends on the relative proportions of the different elements, you must have some means of judgement and measure in order to place your most important object correctly in the picture space.

VISUAL CENTER

The intersection of the vertical and horizontal lines locates a spot, which is termed the "Visual Center."

To place a single object correctly within a given space in harmonious relation to that space, we first draw a rectangle and divide the top and side of the frame lines into five equal parts as shown. The intersection of any of the sets of heavily marked horizontal and vertical line combinations drawn from the numbered divisions will give you what is known as the aesthetic center of the picture area. Having found this aesthetic center, you have established a starting point within the working area. Remember that only one of these points should be used in an arrangement for the placement of your principal object. The object should not be placed exactly over the aesthetic center.

The reason for locating the visual centers on these diagrams is that they establish points in the picture area, which have a proven magnetic influence on our sense of vision that is pleasing and restful—and give our aesthetic sense real satisfaction.

AREAS IN BALANCE

While balance is easily obtained by relying in symmetry, the resulting painting will be static. If you want a sense of movement in a painting, balance must be accomplished by the arrangement of asymmetrical areas, regardless of proportion (you aren't required to break a square surface into equal parts). Just as shapes and forms in your picture are important, so are the spaces between these shapes and forms. If there are crowded areas in your picture, you can often balance them effectively with other simple or vacant areas. Strive for balance in every element of your picture.

Center of Interest

In my paintings, I consider the entire painting to be a "center of interest." However, there are usually one or more dominant shapes that draw the viewer's attention.

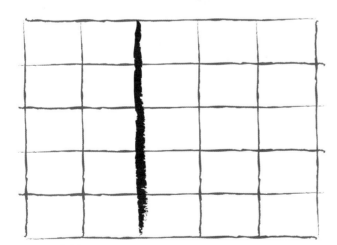
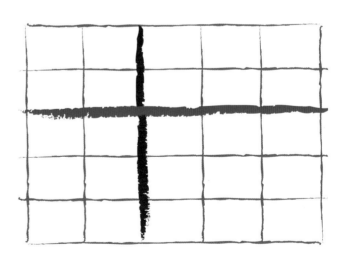

Space Division
The simplest method of establishing the visual center of a picture area is to first divide the space into equal parts. Using this grid, subdivide the picture plane vertically (red) and then horizontally (blue). Where these lines cross, you'll have a natural point for placing your center of interest.

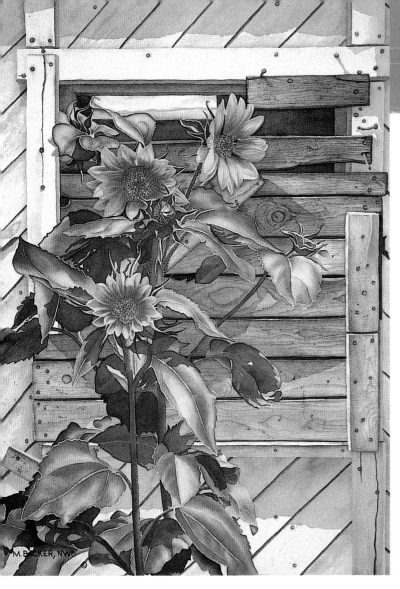

A Well-Balanced Design

The vertical format of this painting adds drama. The wood boards are not symmetrical, and yet this arrangement of shapes is balanced. The plant shapes break up the wood design, softening the overall effect, and adding warmth with its color.

BOARDED UP
Watercolor on Arches 300-lb (640gsm) rough-pressed
41" × 29" (104cm × 74cm)

Simple Distribution of Space

The first row of images shows compositions with an equal distribution of space. Balanced, yes, but monotonous, these designs have the effect of hitting the same note on the piano.

The second row shows compositions with space divided unequally. The areas are no longer the same. Observe that the lines haven't changed, only their position in the picture space.

The third row takes the division of space from the previous row but gives the lines movement. The areas become more intriguing.

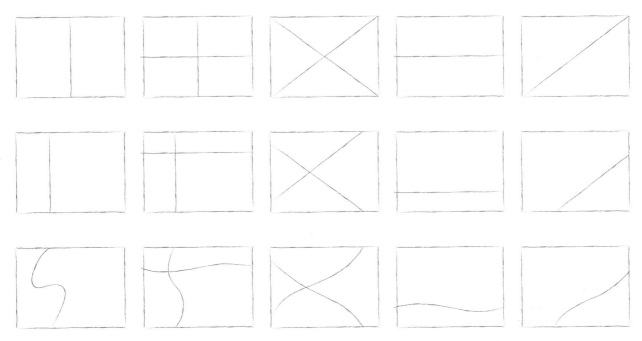

Space and Perspective

A painter is limited to a flat surface on which to create an illusion of depth. This is known as the picture plane. An artist can imagine a scene, can visualize it, and has an imaginary vertical flat picture plane before him. He draws on the paper what he "sees" on the imaginary plane.

Perspective is the art of representing objects on a flat surface so that they appear to recede in distance and give the effect of depth. Traditional perspective relies on lines that appear to converge at a vanishing point on a distant horizon. This method of *linear perspective*, taught in basic drawing class, needs to be understood and put into use by anyone serious about art.

There are, however, other methods of creating different sensations of space that work in painting flowers. Unless you are painting a landscape, you need not be concerned with the infinite horizon. (Your viewpoint will be in your mind as you visualize your subject.) The ancient Chinese landscape painters described three viewpoints as appropriate to art: looking up, looking down and looking across.

- *Overlapping shapes*, another method of providing perspective, creates the illusion of distance by positioning one object in front of another.

- *Atmospheric perspective* is a method regularly used by realistic painters. The atmosphere contains water vapor that obscures objects viewed at a distance. This veil affects the value range, hue, intensity and visible surface detail of distant objects. As objects recede they become grayer and colors become cooler (moving toward blue or violet). In nature, as well as on the palette, cool colors recede, while warm ones advance.

- Similarly, the *push back* method, sometimes referred to as "push-pull," is based on the idea that dark recedes and light comes forward. By pushing back the space behind objects with a softened halo of a cool dark, the light objects are pulled forward and feeling of depth is enhanced.

- With the *diminished repeat* method, objects in space appear to grow smaller in the distance, and the detail and surface texture disappear. By repeating an object in several diminishing sizes, the artist creates a sensation of distance.

- *Cast shadows* also help establish depth. A light source can be a logical, single light, which I prefer, or there can be multiple light sources. Shadows move along the horizontal ground plane and possibly up a neighboring vertical plane, establishing form and distance between objects. With multiple light sources, shadows can be pushed in various directions to balance the design and distribute the effect of spatial sensations.

Color perspective (both atmospheric and push back methods), diminished repeat and cast shadows are tools that I use most frequently to establish perspective. These tools aren't formulas that must be used consistently throughout your painting. Trust your instincts as your painting develops.

Overlapping Shapes

Push Back

Cast Shadows

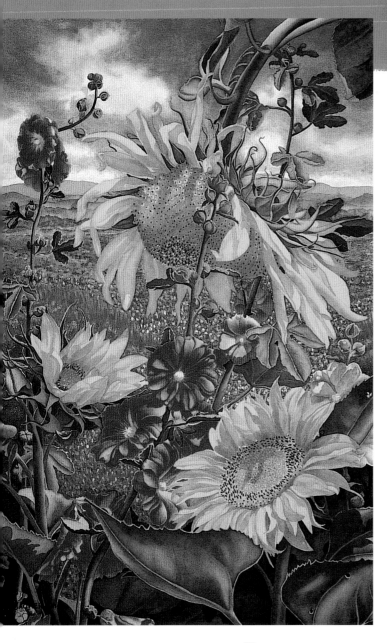

Combining One Set of Perspective Methods

Receding objects are grayer; the colors are cooler, moving toward blue or violet. Detail and surface texture disappear. The dark value and warm colors in the foreground advance toward the viewer. This is the effect called "atmospheric perspective." The objects in space appear to grow smaller in the distance. By repeating an object in several diminishing sizes, the artist creates a sensation of distance.

RAZZMATAZZ
Watercolor and acrylic on Arches 550-lb. (1155gsm) rough-pressed
41" × 29" (104cm × 74cm)

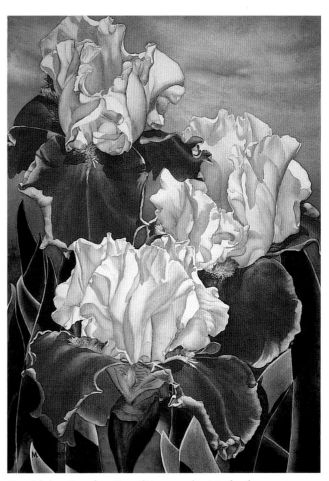

Diminished Repeat

Combining Another Set of Perspective Methods

The subject has been brought forward on the picture plane, creating drama and giving a strong sense of space. The overlapping shapes also contribute to a feeling of limited depth. The cool background sky recedes giving the illusion of greater depth. Cast shadows establish form, help to balance the design and further emphasize the perspective.

JUBILATION
Watercolor Arches 550-lb. (1155gsm) rough-pressed
41" × 29" (104cm × 74cm)

MATERIALS LIST

tracing paper · graphite transfer paper · tape · Pentel pen · watercolor paper

Multiple Sizes

It is helpful to prepare a grid for each of the paper sizes that you normally paint on, and then you have it ready to use. You can use an inexpensive watercolor paper for this process. Some artists re-draw the grid in pencil, lightly, on the paper that the image will be painted on. Others like me, pencil in lightly a center line, one vertical and one horizontal on the watercolor paper, thus ensuring that the tracing will be lined up correctly before it is transferred.

Now that you have an idea of what composition is all about, it's time to try actually constructing a composition. I find working with tracing paper and grids to be very helpful for planning a painting. With this method, you can solve composition problems in the preliminary drawing, before you even touch your watercolor paper.

The grid helps you place important shapes according to the distribution of space, helping you find the ever-important balance of the painting.

The drawing itself is done on tracing paper. The chief advantage of this thin, transparent paper is that it enables you to avoid repetitious work. You can refine your composition easily, and move objects wherever you like, without going through the laborious process of drawing the entire picture over again. You can refine your drawing by making more careful sketches over rough sketches.

You can make complete drawings on the tracing paper and re-use the drawings. This is helpful in case there is a major goof in the painting process and you must begin the painting from scratch or you decide to change a shape or add one. The tracing paper drawing is your "master drawing." You can make changes as often as you desire before committing the drawing to the watercolor paper.

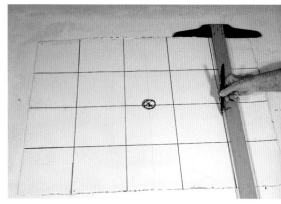

1 DRAW THE GRID
Prepare a grid on a piece of watercolor paper about the size of the planned painting. Mark five vertical lines and five horizontal lines, like the grid on page 22, using a black Pentel pen.

There are many ways in which tracing paper can save you time and trouble. It will pay you to experiment as much as possible to discover how it can serve you.

Many artists today are using the computer at this stage. A computer can be a terrific tool: with it, you can move different elements around, change sizes and colors easily, print the new design as a guide, and solve all kinds of composition and color problems. The computer is another way, along with the camera, that gives you an opportunity to express the way that you see things.

Take every technical short cut you can—but never try to make artistic short cuts!

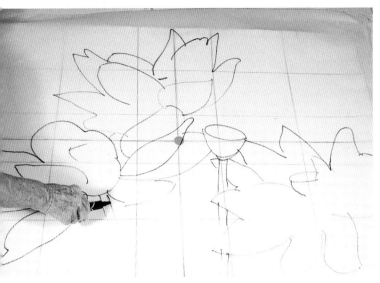

2 DRAW THE FIRST COMPOSITION

Place a piece of tracing paper on top of the grid. Draw the first, rough version of your composition on the tracing paper, using the underlying grid as a guide for the placement of the objects. Don't concern yourself with detail at this stage. You're just arranging shapes. This is just a "rough" sketch, usually of the main blossom, on which to build a pleasing composition around.

3 REARRANGE AND REDRAW

On separate pieces of tracing paper draw the additional shapes that you want to include in the composition. Slip these drawings under your original sketch to see how they will look, rearranging as needed. Add other objects to the foreground, attaching them with bits of masking tape until the arrangement pleases your eye. Then place a sheet of tracing paper over your final layout and trace.

4 TRANSFER THE COMPOSITION

When you have the composition that you want, you can transfer the image to the watercolor paper. You can project or draw the shapes that you have chosen directly onto your paper, or you can use graphite transfer paper. If you're using transfer paper, use a black Pentel pen to copy the outline of your subject; pencil will not always transfer satisfactorily. Tape the corners of the tracing paper down so the drawing doesn't slip as you work.

Graphite transfer paper will smudge, so try to have a light touch with your hands and arms leaning on it; avoid moving or rubbing it on your watercolor paper. When your transfer is completed, lightly erase any smudge marks. Correct your drawing, lightly erase unwanted pencil marks and you are ready to paint in the first wash.

3

The Techniques

WATERCOLOR HAS THE VIRTUE OF BEING adaptable. It can be pastel-soft and ethereal on the one hand, and bold and heavy on the other. This is a balance that suits the painting of flowers: some are soft and delicate, and others are bright and bold.

I've never followed any rules in my work, never consciously thought about technique. Each painting is merely a result of trying to put on paper, with pigment, water and brushes, an image of the emotion that stirred within me the urge to create.
—Eileen Monaghan Whitaker

In this chapter, you'll explore the watercolor techniques that I have found to work the best for painting flowers. This isn't a comprehensive, textbook instruction in the use of watercolor techniques. Rather, it's a concentration on the techniques that work for painting flowers and the backgrounds that complement them. The majority of my work is based on the wash technique, as well as glazing, wet blending and wet-into-wet applications. These techniques will give you ultimate control in building your painting. In addition, you'll learn how to really intensify your painting by adding acrylics to your palette.

When you're comfortable with these techniques, you'll learn to incorporate them into creating backgrounds.

PINK PARFAIT | *Watercolor on Arches 500-lb. (1050gsm) rough-pressed* | *29" × 41" (74cm × 104cm)*

The Wash

A "wash" is a coat of paint. Properly applied, layers of wash produce a glow that can't be achieved by any other means. J.M.W. Turner, the British painter, was one of the greatest masters of this approach. He achieved a remarkable luminosity in his watercolor paintings.

The basic wash, frequently called a flat wash, isn't the only kind. The graduated wash is just as it sounds: the color gradually becomes lighter and lighter.

VARIATIONS ON THE WASH

The process of brushing on washes and allowing them to dry in layers isn't the only watercolor technique. Using the wet-in-wet method to apply color creates many different results, and is a good technique for backgrounds in flower painting.

Graduated Wash

The graduated wash is also painted on dry paper. To achieve this gradual transition of color, load your brush with pigment. Using the same method as the flat wash, bring the wash down the paper about halfway, then dip your brush into clear water and continue down the sheet with clear water. This will pull a little color with it.

Wet-into-Wet

These three washes were painted wet-into-wet to allow the colors to bleed into each other, making a subtle transition. To paint wet-into-wet, first wet the paper with a larger brush. Because you want to the paper to be damp, not sopping wet, wait until the shine of the water has just faded away. You'll get the perfect level of dampness that way.

Here, mix Ultramarine Blue, Cobalt Blue and Cerulean Blue, keeping the mixture somewhat watery but strongly pigmented. Using your largest brush and beginning at the top of the sheet, bring the blue halfway down the page. Load a fresh no. 10 round brush with Alizarin Crimson, and apply the color into the lower part of the blue and beyond. Into the Alizarin Crimson, apply a few brushloads of the Aureolin Yellow, extending that to the very bottom.

Flat Wash

A flat wash is best painted on dry paper. For a successful flat wash, fully load the brush with saturated color. Beginning in the upper left hand corner of the paper, apply the paint, working across and down the sheet until it is covered with paint. One of the secrets is to keep the edge of the paint wet, so keep your brush loaded with the paint. Once the paper is covered and dries, you'll have the basic flat wash.

Granulated Wash

With some sedimentary pigments (Cerulean Blue and Cobalt Blue, for example), you can get a wash with granulated effect. Getting the right ratio of water to pigment can be tricky, so experiment with your colors.

Glazing Color

Glazing is layering a thin, transparent wash of color over another. Learning to control watercolor through glazing gives you more control over the execution of the painting. By using layers, you can produce shades and subtle nuances of color that are impossible to duplicate in any other way. As you work with glazes, you notice that these cumulative layers of different pigments have more luminosity than the same pigments mixed and applied in a single wash.

You can use glazing as little or as much as you like in a painting. You may elect to glaze only the sky, or may use the approach to enhance only the center of interest. Perhaps you may decide to develop the entire painting in this manner. Take time to experiment and explore various combinations of color and how they react upon the paper. Before you begin here are a few tips to assist you.

- Develop your glazes from transparent watercolors.

- Begin with your lightest pigment, usually a yellow.

- Keep your washes diluted and transparent.

- Make absolutely sure that all previous washes are completely dry before a new wash or glaze is applied.

- Use the more opaque paints toward the final stages of your painting, unless you are trying to achieve a special effect. Using them in the early stages of your painting runs the risk of creating muddy or chalky washes. If you do try to paint over opaque pigments, try to make only one pass and don't go over the area again.

In this exercise you are going to explore the cumulative effect of stacking transparent washes, one on top of the other. As the artist you are free to carry the process as far as you like. You will find it possible to model values and shadow passages with subtle gradations of wash. There will be times when you will find it desirable to place many washes in a given area in order to achieve a certain effect.

Layering the Primaries
In this study of glazing, I worked with the three primary colors. I laid down a wash of Aureolin Yellow, then glazed circular area with Rose Madder and then another with Cobalt Blue. The red and yellow layering produced an orange; the blue and yellow made a green. (I also laid a circle of violet—yellow's complement—to produce a gray.)

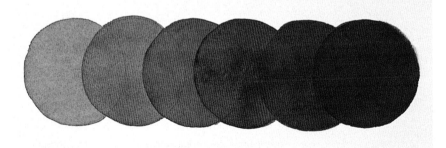

Building Color Intensity
To build up the value and intensity of your color, you can glaze the same color repeatedly. In this example, I've laid down a wash of Alizarin Crimson, let it dry, and then layered the same red over the first layer. I repeated this five times, letting each layer dry before proceeding. This will be the highest intensity of this red, and about as dark as this color gets. Use this technique to build up your paintings in a slow, controlled fashion.

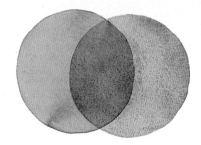

Glazing Complements
Paint two overlapping circles. Paint one Rose Madder Genuine and the other Viridian Green. Where the green overlaps the red (both complements), a grayed neutral will result. You can mix these on the palette, but the glazed color will be "cleaner" and more transparent.

Glazing Graduated Washes

MATERIALS LIST

PAINT
Alizarin Crimson • Aureolin Yellow • Cerulean Blue • Cobalt Blue • Rose Madder Genuine • Ultramarine Blue • Viridian Green

BRUSHES
no. 10 round (sable or synthetic)
1-inch (25mm) flat

OTHER SUPPLIES
paper towels • watercolor paper

This exercise teaches you how to glaze graduated washes to create a beautiful soft sky for backgrounds that don't compete with your main subject matter.

1 LAY THE FIRST WASH
Beginning at the bottom of the sheet, paint a graduated wash of Aureolin Yellow. Let dry.

2 ADD ANOTHER WASH
Start at the top and paint a graduated wash using Rose Madder Genuine. Bring it down to the bottom over the first wash of yellow. Let dry.

3 ADD THE FINAL LAYER
For the final layer, create a medium value blue mixture from Cobalt Blue, Cerulean Blue and Ultramarine Blue. Begin at the top using your largest brush, paint loosely, sweeping across the surface and keeping the edges wet. Keep the color more saturated at the top and add water to bring it all the way down to the bottom. Let dry.

Lifting Paint

Lifting pigment from the paper is a very effective technique for altering an image. Only use these methods when you don't intend to add any additional layers of color to the area. The techniques for lifting pigment can be quite rough, and damaged paper will not react to a fresh wash of paint the way undamaged paper will.

The exception to this rule is using acrylic. You can seal the altered area and continue to paint with acrylic pigment.

LIFTING LARGER AREAS

Should you need to wash off an area of a painting, there are several methods to use depending on the size.

- If the area is small, a damp sponge will usually do the job.

- If the area is larger, you can submerge your sheet of watercolor paper in the bath tub, using 1-2 inches of water to cover. Let it soak for 15-20 minutes, and then using a soft brush, gently rub the affected area. Lift the paper out of the tub and let dry. You can also use this method to wash down the entire painting, leaving a faint imprint of the subject to repaint.

- A more drastic measure is to take your painting outside and spray with a hose. For some artists, this becomes part of their technique.

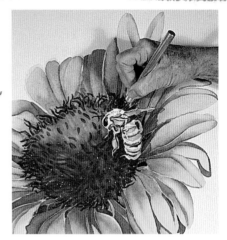

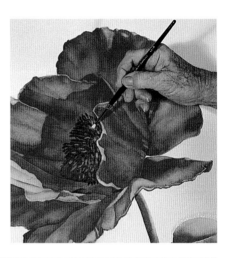

Lifting Color With a Craft Knife

Lifting Dry Paint With an Eraser

**Lifting Color With a
No. 0 Scrubber Brush**

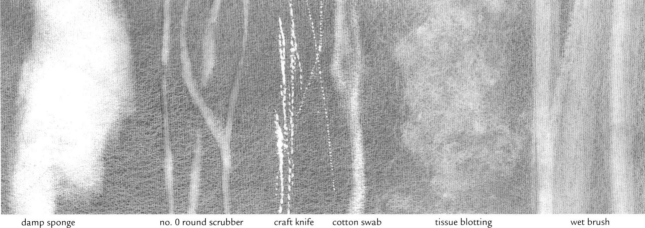

| damp sponge | no. 0 round scrubber | craft knife | cotton swab | tissue blotting | wet brush |

Lifting Pigment

There are various ways to remove pigment from the paper, each with a different effect. This illustration shows several methods of taking paint out of an area (from left to right): sponging out a dry wash; rubbing out a dry wash with a no. 0 round scrubber brush; scraping out with a single-edged razor blade; lifting from a damp surface with a damp cotton swab; lifting out a wet wash with a tissue; lifting out a wet wash with a wet brush.

Other Techniques

There are other ways to manipulate watercolor pigment on the paper, including losing the edge, wet blending, spattering and charging color.

Losing the Edge

In this illustration, the sharp edge of dry paint has been softened by running a damp brush along the edge and blotting with a tissue.

To lose an edge while the paint is still damp, run a damp brush loaded with clear water along the edge and let the color bleed into the damp area.

Charging the Color

This illustration shows you the effects of charging color into color using the wet color into wet color.

Spattering on a dry surface

To spatter using a toothbrush, load a damp brush with pigment and run your thumb along the bristles to spread the paint. Be sure to protect areas that you don't want spattered. This image shows pigment spattered on a dry surface.

Spattering on a damp surface

This image shows paint spattered on a wet surface. The pigment bleeds into the water, creating a more subtle effect than dry spattering.

Backgrounds

Backgrounds are important to your painting. Planning them should take place in the initial stages of your painting. If you don't want a background, leave the paper white or tint it with a color (I prefer a tint of Cobalt Blue).

If you are planning to include a landscape or a skyscape, where you place the horizon line will influence the design of your composition. A high horizon will give you a stronger foreground, while a low horizon will produce a strong sky. The horizon line is a powerful dramatic statement; use it to your advantage to enhance your painting, but not so much that it takes away from your main focal point of flowers.

There will be times when you might want to add a landscape background to your flower painting. These little landscapes are fun to paint and add a dimension of depth and interest to your work. They can be quite simple, from your imagination, or you can refer to your reference file for ideas. A mountain, a lake, a field of wildflowers, a meadow with deer; let your imagination guide you. My suggestion is to have several sheets of paper ready with your outline drawing in place, this way you can do numerous variations, and it is also good practice painting around shapes.

The background hills I painted a pale tint of Cobalt Blue, bringing them down with clear water into the field below.

After drawing the foreground outline directly on the paper, I planned where to place my horizon line, then I worked my way down the page.

For this row of hills, I added Rose Madder Genuine to the blue mixture (Cerulean Blue, Cobalt Blue and Ultramarine Blue). As I painted I lost the lower edge. When this dried, I glazed the closer hills with Viridian Green.

The blue of the sky is a mixture of Cerulean Blue, Cobalt Blue and Ultramarine Blue. I began in the upper left-hand corner, freely painting with the blue mix, going around the areas that would be clouds.

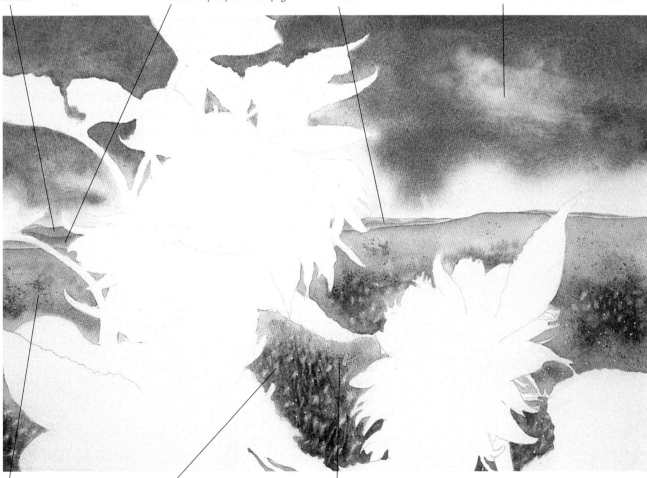

I spattered paint to give the impression of vegetation and add texture.

I lifted out lighter areas using the lifting brush, a cotton swab and a single-edged razor blade

I painted the bottom of these hills Quinacridone Gold, wet blending in New Gamboge. Into the New Gamboge, I wet blended Viridian Green. As I neared the bottom of the paper, I deepened the green, blending it into the previous green. I dabbed Burnt Orange and Cobalt Blue into the green while it was still wet to suggest vegetation.

MATERIALS LIST

Arches 300-lb. (640gsm) rough-pressed
41" × 29" (104cm × 74cm)

very Large

BRUSHES
nos. 8, 10 round (sable or synthetic)

PAINT
Alizarin Crimson • Aureolin Yellow • Cadmium Orange • Cadmium Yellow • Cobalt Blue • Cobalt Blue Deep • Manganese Violet • New Gamboge • Permanent Green • Permanent Magenta • Permanent Rose • Phthalo Blue • Phthalo Green • Rose of Ultramarine • Sap Green • Scarlet Lake • Turquoise Blue • Ultramarine Blue • Viridian Green • Yellow Ochre

OTHER SUPPLIES
tracing paper • graphite transfer paper • no. 2 pencil • eraser • paper towels • tissue

Sky backgrounds for your flower painting can strongly influence the mood. A clear sunny day, a cloudy day, a spring sky with a rain storm approaching, the choice is yours to make.

In a cloudless blue sky the zenith of the sky is always darker than the low sky, with a gradual change in value between them, because the atmosphere, which has an even thickness of air, follows the curvature of the earth. You're looking into outer space through less atmosphere; therefore the color is darker. When you look at the horizon, you look through a thicker layer of atmosphere, so the color of the sky is influenced by the color of the atmosphere and appears lighter.

Since the sky constantly changes in hue as well as in value, you can take advantage of these shifting colors and exaggerate them. I never mix a single blue for the entire sky, and often will underpaint with a yellow and red.

My approach in painting a sky or background is to use my largest brush, usually a no. 10 round. I paint the washes onto dry or occasionally pre-wet paper, and let the brushstrokes blend as they touch. Sometimes I add clear water to blend the sky downward. I don't try

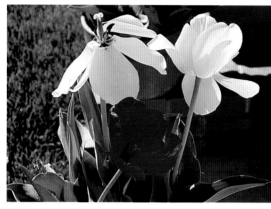

Inspiration
One day this past spring as I was out walking in my neighborhood, I came across tulips in bloom. The day was crisp and spring like with rain clouds gathering. When I arrived home I decided to paint a few tulips. As I began to paint, the rain storm hit. It seemed a fitting background for the flowers. Here is how I created the painting.

for a mechanically spaced, even rhythm, but an intuitive gesture. This is an opportunity to design an interesting balance of colors and texture. This is a good subject to experiment with. Use your reference file for gathering sky ideas.

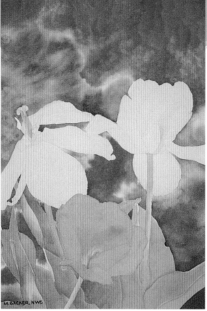

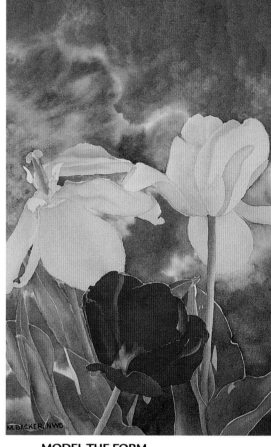

1 ARRANGE SHAPES AND LAY FIRST COLORS

Arrange your shapes using tracing paper and a grid. When you're satisfied with the arrangement of shapes, draw the outline of the shapes onto the watercolor paper. Using a no. 8 round and a tint of Aureolin Yellow, paint the yellow flowers. Use this same color to paint the center of the red tulip, wet blending into the petals. Paint the red petals a medium value of Scarlet Lake.

For the leaves, create three mixtures. First, create a mixture of Cadmium Yellow and Permanent Green. The second mixture, for the blue-greens, should be Cadmium Yellow, Permanent Green and Cobalt Blue. Create a "green-green" mixture of New Gamboge, Viridian Green and Cobalt Blue. Paint the leaves and let dry. Outline the clouds lightly in pencil.

2 PAINT THE SKY AND CLOUDS

Turn the paper over and spray it with a mist of water. Lay a drawing board over the surface for 20 minutes to flatten the paper. Turn the paper face up and place paper towels around the edges of the paper. Wet the outline of the clouds with clear water to prevent a hard edge from forming around the cloud. Using a no. 10 sable round brush and a mixture of Cobalt Blue, Cobalt Blue Deep and Ultramarine Blue, lay a blue wash over the blue sky area. Lightly blot the damp surface with a tissue to create cloud shapes.

Create a gray mixture of New Gamboge, Scarlet Lake and Cobalt Blue and apply it freely to the cloud shape. Wet the edges as necessary then drop in Manganese Violet and Cobalt Blue. Let the colors bleed into the cloud.

3 MODEL THE FORM OF THE FLOWERS

Model the form of the yellow flowers with Cadmium Yellow. Where the sun comes through the petals, the flowers are warmer. Apply Cadmium Orange to this area.

Paint the red flowers using Scarlet Lake, modeling the form as paint is applied. Glaze the stems and leaves with New Gamboge, Viridian Green and Ultramarine Blue, again modeling the form as they are painted.

Un-flat-tering Photography

Photographs often will flatten the image, so I like to go over the shapes and round them out to make them appear fuller and natural.

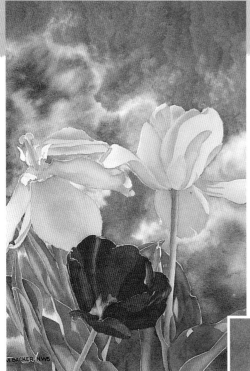

DEEPEN THE CLOUDS

4 Deepen the clouds with the original blue mixture (Cobalt Blue, Cobalt Blue Deep and Ultramarine Blue) as needed, wet blending the color into the existing wash.

For the shadows on the yellow tulips, tint the area with a mixture of Permanent Rose and Sap Green. For shadows on the red flower, use Permanent Magenta. A mixture of Cadmium Yellow, Phthalo Green and Phthalo Blue works for the deeper greens and shadow on the leaves.

Glaze the yellows Aureolin Yellow in the non-shadow areas and Yellow Ochre in the shadows. Glaze the leaves with Turquoise Blue in the cooler shadow areas. Glaze the red flower with Scarlet Lake.

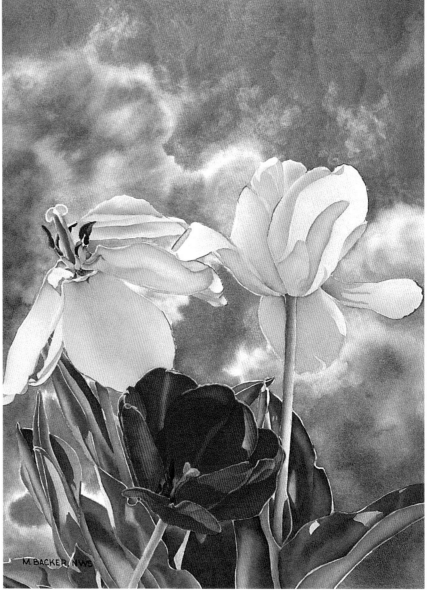

FINISH THE PAINTING

5 To finish the painting, paint the darkest on the leaves using a mixture of Cadmium Yellow, Phthalo Green and Phthalo Blue. Layer the red tulip with several reds—Scarlet Lake, Permanent Magenta and Alizarin Crimson—to build up the dark passages, blending as the paint is applied. Glaze the yellow flowers with Scarlet Lake to add warmth. Glaze the shadows with a tint of Sap Green. To create the black stamen on the red tulip, paint them a dark mixture of Alizarin Crimson and Phthalo Green. Add touches of brown to the yellow flower with a mixture of Cadmium Yellow and Scarlet Lake, mixed to a rich orange, then add a little Phthalo Green.

APRIL SHOWERS
Watercolor on 550-lb.(1155gsm) Arches rough-pressed
41" × 30" (104cm × 76cm)

Watercolor is resoluble. Because it lifts so easily, layers of color can mix unexpectedly, creating a muddy statement that lacks punch. Acrylic paints, when applied over layers of watercolor, act like a transparent barrier protecting your underpainting, allowing you to add more paint to a surface that's locked into place. This doesn't mean that you have to give up the look of glowing, transparent watercolor. The watercolor underpainting still shines through. You can also apply acrylics only to portions of your painting for various effects and making corrections that are impossible with watercolor. You can create delicate color harmonies, a vibrant surface and an internal glow of light. You can work layer upon layer to form a painting without lifting the underlying layers.

A traditional watercolor painting is made with layers of pure, transparent watercolor. No white paint, no black paint. Although corrections are possible, there is a limit to what you can do to help your painting if it goes bad. If your colors are dull, flat and unexciting, try adding some punch with layers of acrylic. You can mix washes in a great range of colors the same as in your watercolors, and the tinting strength is excellent. You can build up deep rich color and darks by applying glaze upon glaze. Like watercolor, acrylics can be lifted from the paper while wet. If allowed to dry, they can be partially lifted with a bristle brush, water and a paper towel for blotting. Alcohol can also be rubbed over dried paint to help remove it. You can also paint over a spot that needs correction with white acrylic or white gesso, and then repaint the area, blending it into the painting.

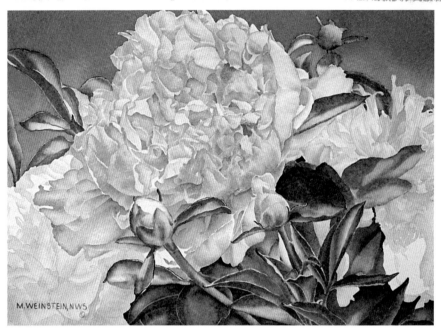

Before Glazing With Acrylics
Before the acrylics are added, the painting is adequate and accurately rendered, but lacking punch.

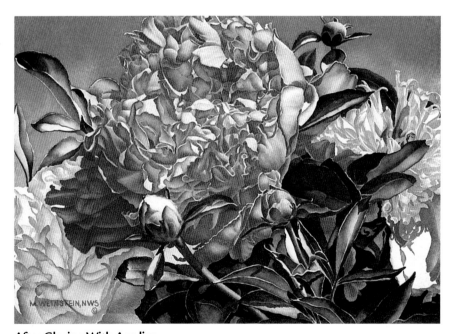

After Glazing With Acrylics
The watercolor still speaks in this painting but the acrylics add intensity and make it a more successful painting.

RASPBERRY SORBET
Watercolor/acrylic on Fabriano 300-lb. (640gsm) rough-pressed
22"× 30" (56cm × 76cm)

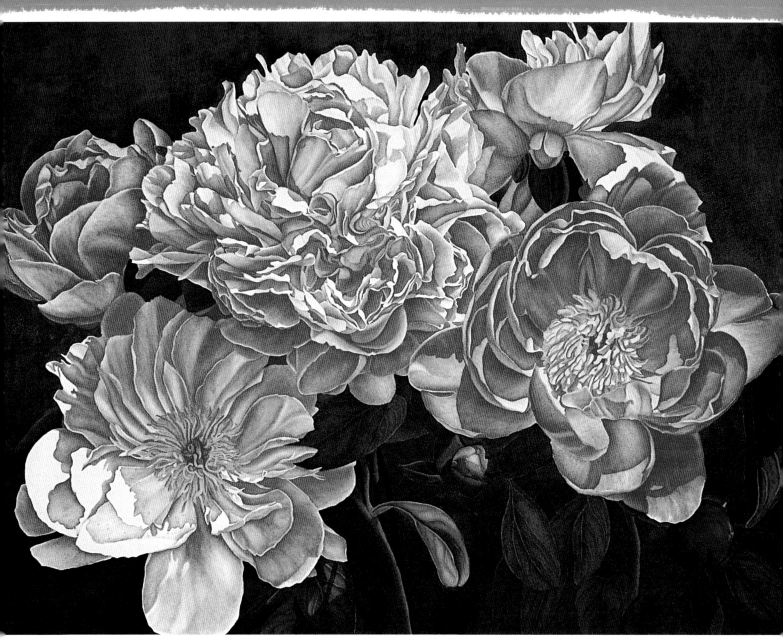

Acrylics to the Rescue

This painting was basically finished, but I felt the background needed a deeper color. I began glazing with Phthalo Blue, but when I reached the upper right hand area, a large resist spot appeared. I tried everything to get rid of it or disguise it, but it just would not be corrected. After all my work, the painting was ruined. After a sleepless night, I remembered some acrylics that were gathering dust in my paint drawer. I gave it a shot. After covering the background with white acrylic, I laid down a rich blue mixture (Cobalt Blue, Phthalo Blue and Ultramarine Blue) plus matte medium. It took two applications, but it worked. *Tickled Pink* went on to win awards and is one of my favorite works.

TICKLED PINK | *Watercolor/acrylic on Arches 550-lb. (1155gsm) rough-pressed* | *30"× 41" (70cm × 104cm)*

MATERIALS LIST

Fabriano 300-lb. (640gsm) rough-pressed paper 22" × 30" (56cm × 76cm)

BRUSHES
nos. 8, 10 round (synthetic)

WATERCOLORS
Cobalt Blue • New Gamboge • Phthalo Blue • Rose Madder Genuine • Scarlet Lake • Ultramarine Blue • Viridian Green

ACRYLICS
Cadmium Yellow • Phthalo Blue • Phthalo Green • Quinacridone Red (Permanent Rose) • Ultramarine Blue

OTHER SUPPLIES
no. 2 pencil • eraser • tracing paper transfer paper • Golden soft gel matte medium • acrylic retarder • spray can of acrylic matte medium • divided plastic plates • paper towels • tissue • clean rags

In this demonstration the painting begins as a traditional watercolor, and then the paper is sprayed with matte medium to seal the watercolor underpainting. You will learn how to mix a medium into the acrylics to allow better brushing qualities of your paint and slow down the drying process so that you can handle the acrylics just as you do your watercolor.

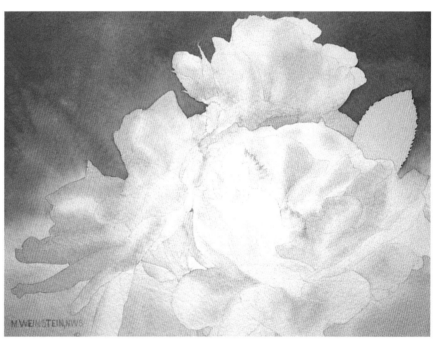

M. WEINSTEIN, NWS

1 LAY IN THE FIRST COLORS

Transfer your drawing to the watercolor paper, correct the drawing and erase any unwanted pencil lines. Mix a good size puddle of New Gamboge. Using a no. 10 round, paint over the bottom section of the paper, using clear water to brush upward until it runs clear. Use the same mixture and a no. 8 round to paint the leaves and warm area of the flowers. Mix a tint of Rose Madder Genuine and paint the petals, using clear water to blend. For the sky background, create a mixture of Cobalt Blue, Ultramarine Blue and Phthalo Blue. Use a no. 10 round to paint the background. Let dry.

2 PAINT THE SHADOWS
Paint the shadows on the flower and leaves with a tint of Cobalt Blue.

A Spray Break

Keep your mix from drying out too rapidly by spraying with water as necessary. When you stop working you can save your mix by spraying and covering it with another plastic dish and weight it down. This is usually good for at least a day or two.

3 STRENGTHEN THE PETALS
Create a mixture of New Gamboge, Viridian Green and Cobalt Blue, then paint the leaves using a no. 8 round. Strengthen the color of the petals with Rose Madder Genuine.

4 BUILD UP COLOR AND MODEL FORM

With a no. 8 round, apply a medium value Scarlet Lake to the warmer rose on the left side. Continue glazing Rose Madder Genuine on the other roses, building up the color and modeling the form. Let everything dry.

5 SEAL THE PAINTING AND LAY DOWN ACRYLIC WASHES

To prepare your painting for the acrylic step, take it outdoors and prop it up against a support. Follow the directions on the spray can of acrylic matte medium, and spray two coats on the paper. Two coats is normally enough to seal the watercolor underpainting.

Place a dollop of Quinacridone Red (Permanent Rose) on a plastic plate; add a drop of retarder and a dab of acrylic gel medium. Add water until the paint has a watercolor consistency. With this mixture and a synthetic no. 8 round, paint the accent colors on the flowers. For the leaves, create a mixture of Cadmium Yellow, Phthalo Green, Phthalo Blue, a drop of retarder and a dab of acrylic gel medium. Add water. With a clean no. 8 round, paint the leaves, deepening the color where needed. Paint a red edge around the leaves with Permanent Rose.

Keeping Clean and Washing Up

Keep your brushes in water while you work so that they don't dry out. Be sure to clean them with soap when you're through painting.

6 FINISH THE PAINTING

For the deep blue background, create a mixture of Ultramarine Blue, Cobalt Blue and Phthalo Blue acrylic pigments in a plastic cup. Add a drop of retarder and a dab of matte medium, plus water and mix well. Use your largest brush and paint the background. When your painting is finished and dry, take it outside and spray three to five coats of acrylic matte medium over the surface. This will blend the watercolor painting into the acrylic. It will be hard to tell where the watercolor stops and the acrylic painting begins.

Acrylic Medium

Acrylic medium can also be added to your watercolor paint. This is useful when you're looking for a color to match your watercolor pigment and can't find it. The acrylic medium will set your watercolor just like an acrylic product.

AMERICAN BEAUTIES | *Watercolor/Acrylic on Fabriano 300-lb. (640gsm) rough-pressed* | *22" × 30" (56cm × 76cm)* | *Collection of Mr. and Mrs. Roger Squire*

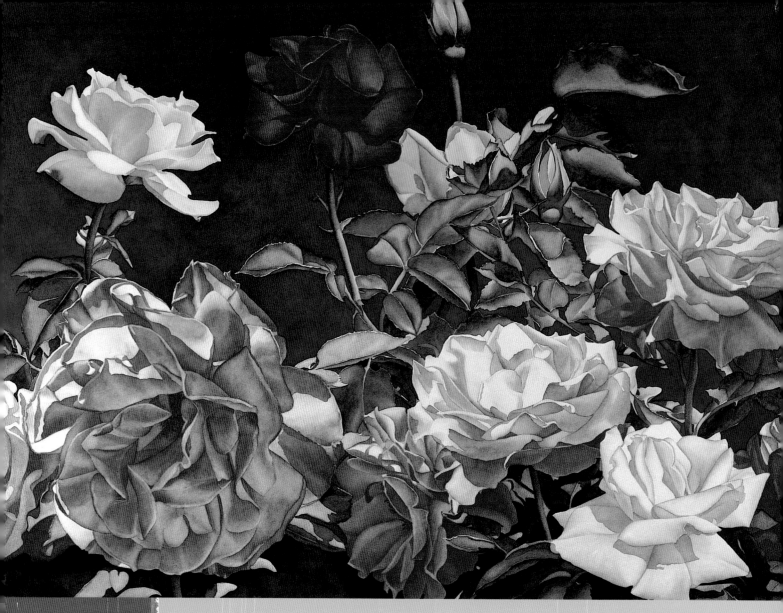

4 Color *Basics*

I found I could say things with color and shapes that I couldn't say any other way—things I had no words for.

—Georgia O'Keefe

COLOR, UNLIKE THE MORE TANGIBLE elements of form, construction, proportion, line, value and composition, is a highly personal and variable factor. In this chapter, you'll learn certain basic principles in the handling of color. Your development as a colorist will depend upon your own imagination, ingenuity and taste.

You can study color theory further, but as an artist, you should be concerned with certain things: how to recognize, judge and control differences in the three dimensions of color—hue, value and intensity.

The material presented here will enable you to judge, describe and color accurately.

You learn to use color by practice of eye and hand. You will be given the information you need, but the most important thing is to apply this information to your own work with color.

COMING UP ROSES? | *Watercolor/acrylic on Arches 550-lb. (1155gsm) rough-pressed* | *29" × 41" (74cm × 104cm)*

Color: What is it?

Color is a sensation we experience when our eyes are struck by light waves of varying lengths. In order for us to see anything there must be light. The rays of light which come to us from the sun we call "white light." It's this white light which contains all the colors we see around us.

All the colored objects around us contain "pigment," which has the ability to soak up certain rays of color, while reflecting others. The pigment in a red ball, for example, reflects only the red rays, and absorbs all the others. A green ball, on the other hand, reflects only the green rays to our eyes while absorbing the others. Place these two balls in a totally dark room and the balls would have no color at all, because there's no light.

Some materials are especially rich in pigment. These materials are carefully selected and purified into the pigment paints you buy in tubes or jars at your local art store. They have been manufactured from various plants, animals and minerals. When you mix these pigments, you are mixing pure color. In other words, you're working with purified pigments which have the special property of reflecting the particular colored waves you want to see, while absorbing all others. As an artist you will be working with pigment colors rather than the color of light.

There is no color or line that you can draw, that will put feeling into your painting, but if you paint with your heart, it will show in your painting.
—Wilson Hurley

The Spectrum

A simple way to demonstrate that white light is made up of colored light rays is to shoot a beam of white light through a glass prism.

This illustration shows a beam of white light entering the prism from the left. The rays are bent as these pass through the glass and emerge at various angles. Since some rays are bent more than others, they are projected as a band of color that we call the "spectrum."

This band ranges from the longest red rays through the progressively shorter orange, yellow, green and blue rays to violet. Countless raindrops caught in the path of white light from the sun act as tiny prisms to break up the light waves into groups of colorful beams, which we see in the form of a rainbow.

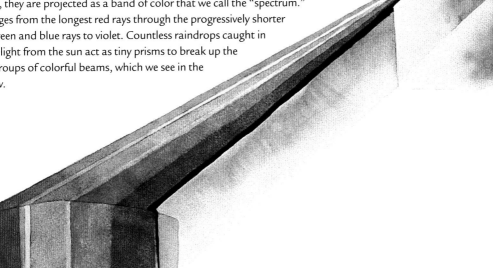

Color Wheel

The first dimension of color is hue. It denotes the position of a color on the color wheel and has nothing to do with whether the color is light or dark, strong or weak.

Red, yellow and blue: we know that we must have at least these three pigments to paint in full color. Orange can be mixed from red and yellow, green from yellow and blue, and violet from blue and red. But red, yellow and blue can't be mixed from other colors and so are called primaries.

Orange, green and violet can be mixed from the primaries, and are therefore called secondary. Colors such as red-orange, yellow-green and blue-violet, which are made by mixing a primary and secondary color, are called tertiary.

Theoretically, neither white, black nor any neutral grays mixed from black are colors. They lack two of the essential color dimensions—hue and intensity. However they're useful for modifying the values and intensities of the colored pigments.

Understanding color relationships is easier if you relate the color spectrum to a color wheel. This is simply the spectrum colors arranged around a circle.

YOUR OWN COLOR WHEEL

The actual tubes of color that you buy in the art store aren't quite the same as those on the color wheel. Instead of lining up on the spectrum, they fall here and there, missing their proper places. One manufacturer's color may differ from another. The color wheel, however inaccurate, is still a useful tool to keep color theory and relationships in mind.

To create your own color wheel, draw a circle about 8 to 10 inches (20cm to 25cm) in diameter on watercolor paper, then divide the circle into six equal parts. Using a no. 8 round brush, paint a swatch of Aureolin Yellow at the top of the circle for yellow; then do the same using Rose Madder Genuine for red and Cobalt Blue for

blue at every other mark around the circle.

Next, you'll need to add the secondary colors: orange, green and violet. You can mix these secondary colors from the primaries, or you can use tube paint. To create orange, mix it from primary yellow (Aureolin Yellow) and red (Rose Madder Genuine). Mix green from yellow (Aureolin Yellow) and blue (Cobalt Blue). Create violet from blue (Cobalt Blue) and red (Rose Madder Genuine). Place these colors on the color wheel opposite of their complement.

Violet goes across from yellow because they are complements. Violet, mixed from blue and red, has no yellow in it and is therefore yellow's opposite, or complement. Blue and orange are complements, and red and green are complements. If you mix a set of complements, you will effectively be mixing all three primaries, which creates gray.

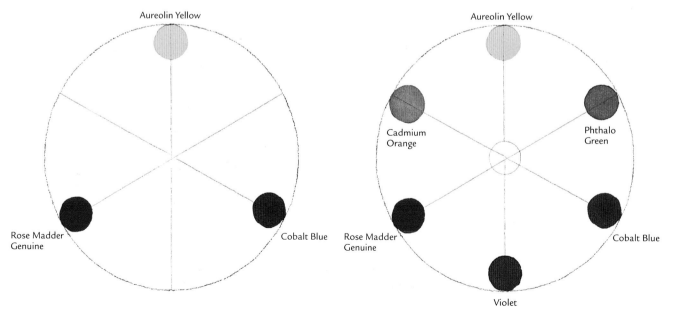

COLOR WHEEL WITH PRIMARY COLORS

Aureolin Yellow

Rose Madder Genuine

Cobalt Blue

COLOR WHEEL WITH SECONDARY COLORS

Aureolin Yellow

Cadmium Orange

Phthalo Green

Rose Madder Genuine

Cobalt Blue

Violet

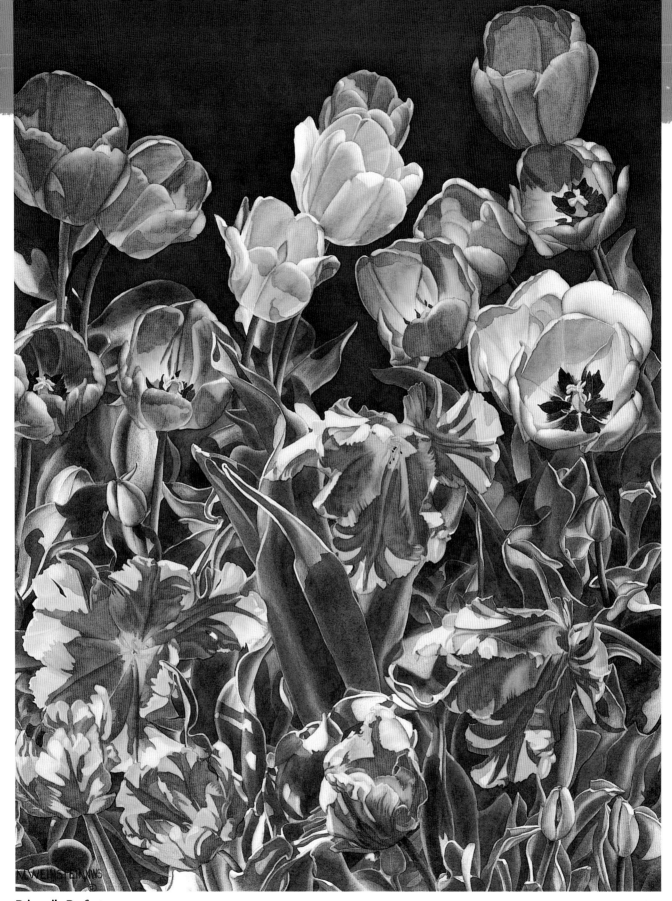

Primarily Perfect

The primary colors—yellow, red and blue—sing in *Tulipmania*. I used a palette consisting of New Gamboge, Cadmium Yellow, Cadmium Orange, Scarlet Lake, Cadmium Red, Alizarin Crimson, French Ultramarine Blue and Phthalo Blue. The greens are mixed from the yellows and blues.

TULIPMANIA | *Watercolor on Arches 550-lb. (1155gsm) rough-pressed* | *41" × 29 ½" (104cm × 75cm)*

Warm and Cool Colors

Colors convey temperature, appearing either warm or cool to the eye. When artists speak of "warm" and "cool" they are discussing qualities of hue, rather than of value or intensity.

It's important to understand the distinction between warm and cool colors, because this quality affects the color's behavior within the painting. Warm colors tend to come forward within the picture, while cooler colors recede into the background.

Now add the warm colors on the left side of your wheel: New Gamboge, Cadmium Yellow, Cadmium Orange, Cadmium Red, Scarlet Lake and Alizarin Crimson.

On the right side of the wheel add the cooler colors: Viridian Green, Phthalo Green, Ultramarine Blue and Phthalo Blue (Cobalt Blue is already there).

If you divide the color wheel vertically down the middle, you would be splitting yellow at the top and violet at the bottom. The reds and oranges on the left side of the wheel are warm and the greens and blues on the right are cool. But what about the yellow and violet? The yellow swatch on the orange side would be a warm yellow, while the yellow swatch on the green side would be a cool yellow. The same prevails for violet; it's warmer toward red and cooler toward blue. In an actual painting, a lot of what makes a color seem warm or cool depends on which colors are next to or around it.

The center represents totally grayed color. In theory, any color can be grayed, or neutralized, by adding some of its complement to it.

Opaque to Transparent

The Cadmium pigments are considered opaque; however, if you thin them down with water, they act like transparent pigment.

WARM-COOL PALETTE

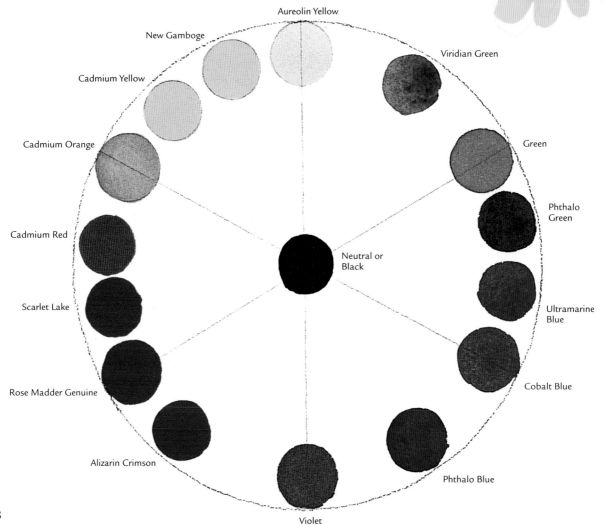

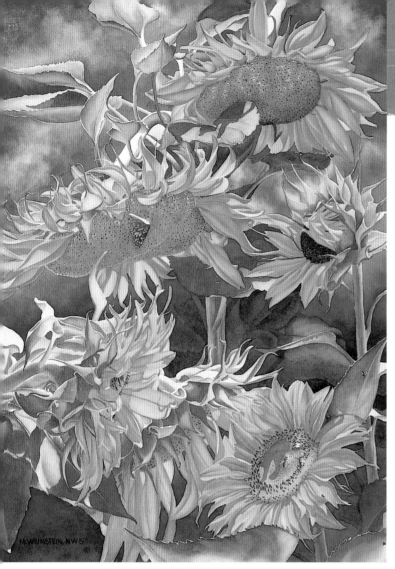

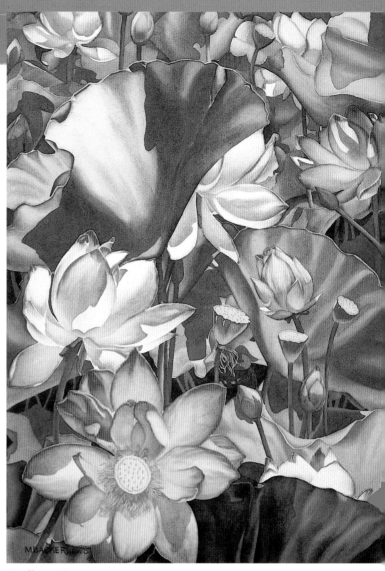

Primarily Primaries, Both Warm and Cool

My palette for this painting was mainly warm and cool versions of the primaries. It was a bright summer day that lit up the flowers and cast shadows on the blossoms and leaves of the plant. The sunflowers were painted using the warm side of the color wheel, including New Gamboge, Cadmium Yellow and Cadmium Orange. The browns are a warm mix of Cadmium Red, Cadmium Yellow and Phthalo Green. The leaves were painted first with New Gamboge and then the deeper greens were layered on in several steps, with the last step being the shadows (Phthalo Blue was used here). The blue sky complements the yellow and oranges in the flower and little butterfly gathering nectar. The cooler deep blue background helps to bring the sunflowers forward. This is a warm and happy painting.

SUNKISSED
Watercolor on Arches 550-lb. (1155gsm) rough-pressed
41" × 29" (104cm × 74cm)

Warming Up to the Viewer

A predominately warm-toned painting will outsell a cool-toned work two-to-one.

Cooling It Down

There is a feeling of coolness in this painting; it was underpainted with the warm primaries, and then layers of cool greens and blues were glazed over the warm underpainting. The shadows are a cool blue, and the background darks are glazes of Phthalo Blue and Phthalo Green. Even the red in the flower appears cool. Touches of yellow and orange in the leaves and the flower centers give a touch of warmth, but overall it's a cool painting. The greens are a complement to the reds. There is a lot of green in this painting, perhaps too much. To me, it's not as visually appealing as the sunflower with its warmth.

THE LOTUS GARDEN
Watercolor on Arches 550-lb. (1155gsm) rough-pressed
41" × 29" (104cm × 74cm)

Value

When we use the word "value" we're referring only to the lightness or darkness of a color. It's as simple as that.

In my work a basic three-value approach is used: light, middle and dark. To this I add a lightest light, the white of the paper and the darkest dark, black. When you're planning your values, it may help to keep light objects against dark objects and dark objects against light objects. Once the value pattern in your painting is established, you simply relate the colors to the values. For example, red at full intensity will appear as a dark. Yellow is the lightest color; only the white of the paper will be lighter. Placing your lights first in your painting will help you plan where to place your darks.

Gray Value Scale
A simple value scale, like this one, going from white to black, helps in understanding values and planning paintings.

The Value of Color
Here I've made a value chart of some of the colors I use most frequently to show you where they fall on my gray value scale. In the actual painting process, you'll work from light to dark using glazing and layering techniques. This method will allow you to build your values with each layer. You'll intuitively know where to place your lightest lights and your darkest darks as you become more proficient in the watercolor painting process.

Ultra Marine Blue Cobalt Blue Cadmium Orange Aureolin Yellow

Cadmium Red

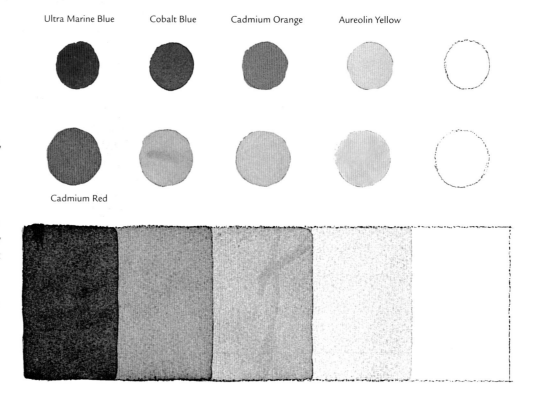

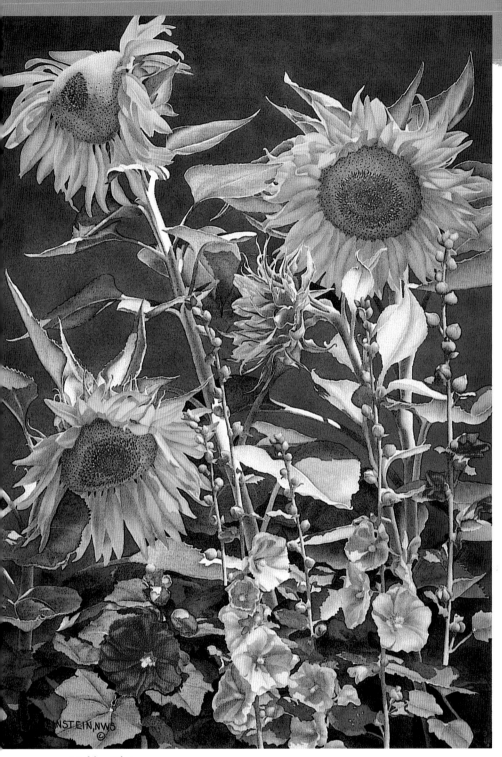

Seeing the World in Black and White
Every color has a value, and different colors can have the same value. A good way to identify value is to think of a black-and-white photograph, and how every color in the scene is converted into gray, black or white values.

Making Tints
When adding water to the original color, you're making a tint of the color. If you were to add black, or the color's complement, you would make a shade of the color. In either case you're not changing the hue, only the value.

SUNCATCHERS | *Watercolor and acrylic on Arches 550-lb. (1155gsm) rough-pressed* | *41" × 29" (104cm × 74cm)* | *Collection of J. Koch*

Intensity

The last dimension of color is intensity. This word refers to the strength, saturation or purity of a color. A pure red of full intensity looks "redder" than when it's diluted with water, gray or some other color. There's more red pigment in the pure red; it therefore has greater ability to reflect the red rays of light.

- Full intensity occurs when you apply color straight from the tube.

- Medium intensity means that the intensity is moderated with a gray or a complement that matched that particular color in value.

- Low intensity occurs when you add more gray or a complement to the color. It is doubtful that you would want to go this low in painting flowers. If so, start with your complement or gray and then add the color.

Colors should work together at every stage of a painting's development. No one color can "sing" more loudly than the others. I achieve that harmony in the way I mix colors and glaze them over the ones already on the paper.

Grays, blacks and browns are used in the painting of flowers. All you need to achieve great color in your darks are the three primaries and their complements. Shown here are three of my favorite mixes. They can be warmed up or cooled down. With more water added, they become a tint. Straight from the tube, they're intense in color. You're striving to keep your colors lively and bright. Instead of mixing a black, try layering transparent red over a green (or vice-versa) to lower its value. A little of the complement grays the intense color only a bit. The more complement you layer, the grayer or more neutral the color becomes.

The Colors That I Use Frequently

YELLOW
Aureolin Yellow • New Gamboge
Cadmium Yellow

RED
Rose Madder Genuine
Alizarin Crimson • Permanent Rose
Quinacridone Rose • Quinacridone Red
Cadmium Red • Scarlet Lake

BLUE
Cobalt Blue • Ultramarine Blue
Phthalo Blue

GREEN
Permanent Green • Viridian Green
Phthalo Green

OCCASIONAL USE
Quinacridone Violet • Permanent Magenta
Cobalt Violet • Burnt Sienna • Sap Green
Cerulean Blue • Neutral Tint

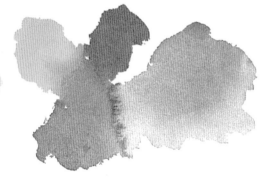

For colorful grays mix Aureolin Yellow, Rose Madder Genuine to an orange and add Cobalt Blue. Working with the primaries and complement, try other combinations of color.

Browns are easy if you mix Cadmium Yellow and Cadmium Red to make an orange and add Phthalo Green. This is the combination that I use for the centers of sunflowers. Try other combinations using other greens. The key is to begin with an orange color.

The best black is mixed from Alizarin Crimson and Phthalo Green. This is a transparent, colorful black. You can warm it up by adding more red, or cool it down by adding more green. Black can simply be a color that is dark enough to *appear* black.

Color Mixes for Gray, Brown and Black

MATERIALS LIST

Arches 1114-lb. (2339gsm) rough-pressed
40" × 60" (102cm × 152cm)

BRUSHES
nos. 8, 10 round sable
nos. 8, 10 round synthetic
3-inch (75mm) flat synthetic

WATERCOLOR
Alizarin Crimson • Cadmium Yellow •
Cobalt Blue • Permanent Green •
Permanent Rose • Phthalo Blue • Rose
Madder Genuine • Sap Green • Scarlet
Lake • Ultramarine Blue • Winsor Yellow

ACRYLIC
Cadmium Red • Cadmium Yellow •
Dioxazine Purple • Naphthol Crimson •
Permanent Green • Permanent Magenta •
Permanent Rose • Phthalo Blue • Phthalo
Green • Ultramarine Blue • Vermilion •
Viridian Green • Quinacridone Red

OTHER SUPPLIES
acrylic matte medium in spray can •
acrylic matte medium, liquid

This is a strong painting with lots of saturated color, not for the faint of heart. Red is a color with the elementary qualities of strength and visibility. Red suggests strong powerful emotions. Green is nature's color and gives the effect of the outdoors and growing plants. Blue suggests distance and a quiet, peaceful atmosphere. None of these colors were grayed to lessen their intensity; cooler pure color was used to indicate shade and shadow.

How Much Water?

Many artists use the brush to bring water into their pigment, but I like to use my spray bottle. Four squirts to start. If that's not enough, squirt some more. If too much water is used, just add more pigment. It'll take time, but you'll find the method that works for you.

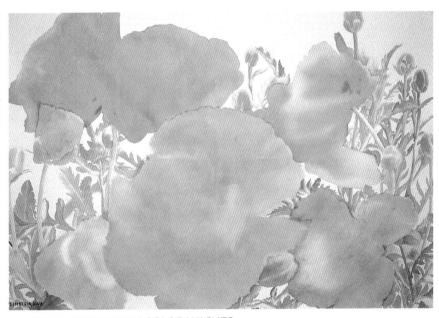

1 LAY THE FIRST WATERCOLOR WASHES

As the first wash, lay a tint of Winsor Yellow over the entire sheet. Begin at the bottom and work toward the top, applying clear water as you go up. Let this dry. Model the form of the flowers with Cadmium Yellow. Paint the leaves using a mixture of Winsor Yellow, Sap Green and Cobalt Blue. Use various tints of red, warm and cool, for the flowers: Permanent Rose, Winsor Red and Scarlet Lake. Apply the tints wet-into-wet. Let the paper dry.

2 MODEL THE FORM

Begin modeling the form of the flowers with Scarlet Lake. When the paint is dry, glaze Rose Madder Genuine over all the petals. Let dry.

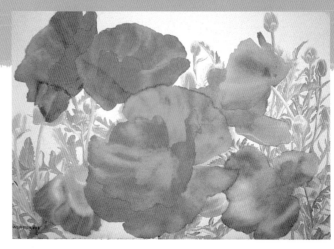

3 SPRAY WITH ACRYLIC MATTE MEDIUM

Spray the paper with two coats of acrylic matte medium. To begin building the color and form of the petals, mix watercolor pigment with liquid acrylic matte medium. Paint the next layer of Alizarin Crimson. Use two mixtures for the background. For the lower area, Cobalt Blue, Ultramarine Blue and Phthalo Blue. In the upper section, a deeper mixture of Phthalo Blue, Ultramarine Blue and Cobalt Blue. The leaves receive more color and modeling using a mix of Cadmium Yellow, Permanent Green and Phthalo Blue. Glaze the petals with a tint of Permanent Rose. Let dry.

4 ACRYLIC PAINT APPLICATION

From this point until the finish, the painting will only be worked with acrylic pigment. Spray the paper again with two coats of acrylic matte medium. Block in the center darks with tints of Dioxazine Purple. Glaze the petals with Vermilion. Glaze the leaves with a mixture of Cadmium Yellow, Viridian Green and Ultramarine Blue, modeling the form. Glaze the entire background with Quinacridone Red.

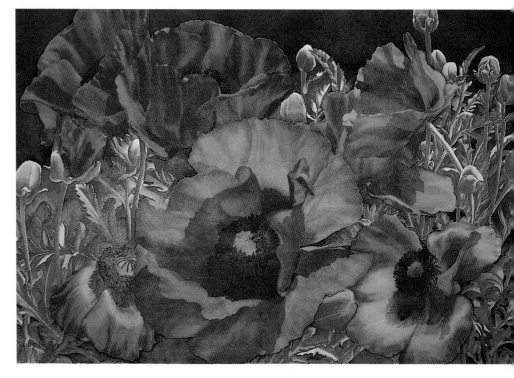

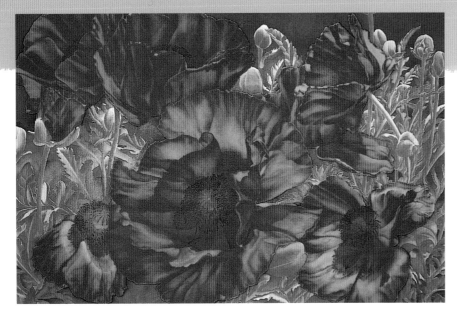

5 CONTINUE GLAZING

Glaze the flowers with separate applications of Permanent Rose, Cadmium Red and Vermilion. The darks in the petals and shadows are Naphthol Crimson.

6 DEEPEN THE GREENS

Deepen the greens with a mixture of Cadmium Yellow, Phthalo Green and Phthalo Blue. In the upper background, bring the glazes of the original blue mix down into the lower portion of the painting, and then charge the area with Phthalo Green, Permanent Green and Phthalo Blue. Bring out plant shapes in the lower background using negative painting and two colors: Phthalo Green and Phthalo Blue. Glaze the shadows in the flowers Permanent Magenta.

GEORGIA ON MY MIND - #3 | *Watercolor/acrylic on Arches 1114-lb. (2339gsm) rough-pressed* | *40" × 60" (102cm × 152cm)* | *Collection of Michael and Nancy Guido*

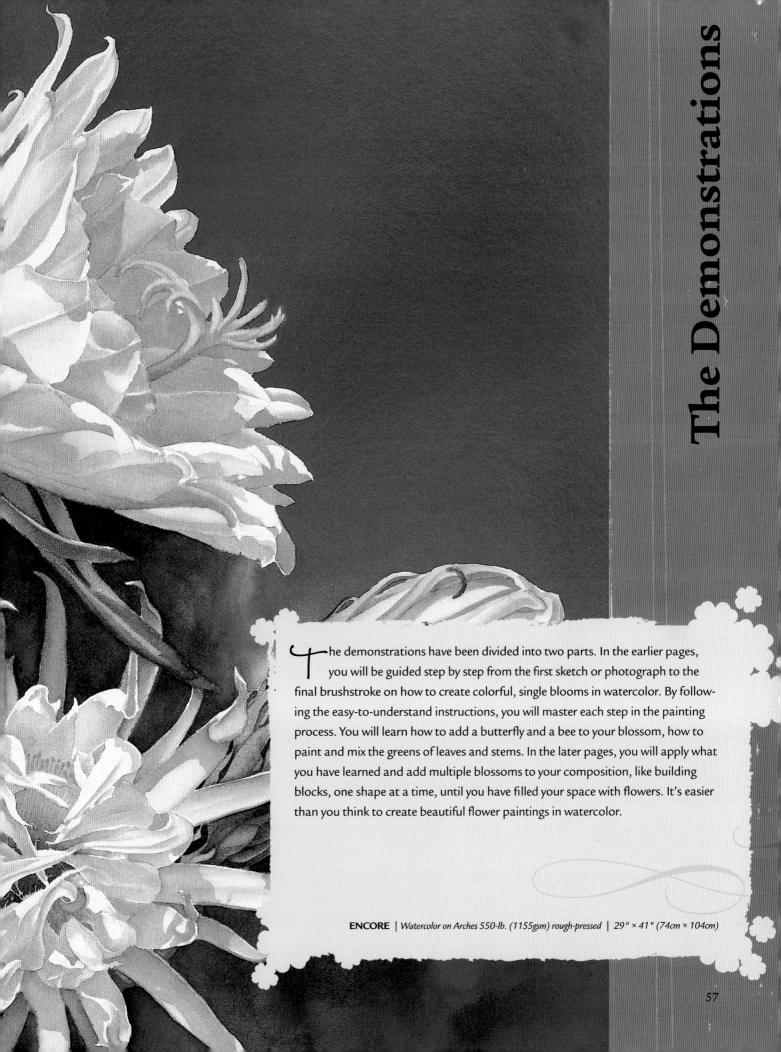

The demonstrations have been divided into two parts. In the earlier pages, you will be guided step by step from the first sketch or photograph to the final brushstroke on how to create colorful, single blooms in watercolor. By following the easy-to-understand instructions, you will master each step in the painting process. You will learn how to add a butterfly and a bee to your blossom, how to paint and mix the greens of leaves and stems. In the later pages, you will apply what you have learned and add multiple blossoms to your composition, like building blocks, one shape at a time, until you have filled your space with flowers. It's easier than you think to create beautiful flower paintings in watercolor.

ENCORE | *Watercolor on Arches 550-lb. (1155gsm) rough-pressed* | *29" × 41" (74cm × 104cm)*

DEMONSTRATION *Tulip*

MATERIALS LIST

Arches 300-lb. (640gsm) cold-pressed
paper 23" × 18" (58cm × 46cm)

PAINT
Alizarin Crimson • Aureolin Yellow •
Cobalt Blue • Phthalo Blue • Rose Madder
Genuine • Ultramarine Blue • Viridian
Green

BRUSHES
nos. 8 and 10 round (sable or synthetic)

OTHER SUPPLIES
tracing paper • graphite transfer paper •
no. 2 pencil • eraser • small sponge •
paper towels

Tulips are a mainstay of spring gardens everywhere, and can provide abundant flowers in a wide spectrum of colors from March through May. Most modern tulips are descended from the oldest tulips in cultivation, the so-called lily-flowered type, which has pointed petals and was so admired by the Turks that it was one of the most popular decorative motifs during the 500 years of the Ottoman dynasty.

"Rosy Glow" grew in my mountain garden, and each spring I looked forward to seeing it peek out above the snow-covered ground, welcoming a new season. You will learn how to capture its glow in this watercolor demonstration.

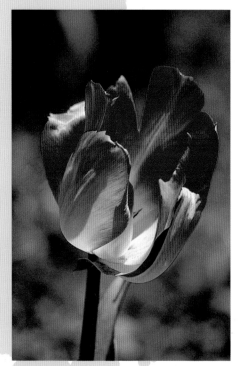
Reference Photo

1 START WITH A TINT OF COLOR
Transfer your drawing to the watercolor paper. Correct your drawing and lightly erase unnecessary pencil marks. Start by mixing a puddle of Aureolin Yellow on your palette, a "barely there" tint. Test the mix on a piece of scrap watercolor paper. It's better to apply paint too light than too dark, but yellow is the lightest color other than the white of the paper, and is easy to correct. Load your no. 8 brush with pigment, then paint the areas that are going to be yellow or green in the finished work. Don't worry at this stage about being precise with your brushwork. If paint gets where you don't want it, simply brush clean water on the area and wet blend into the petals, or blot it with a tissue or paper towel. Let dry before going to the next step.

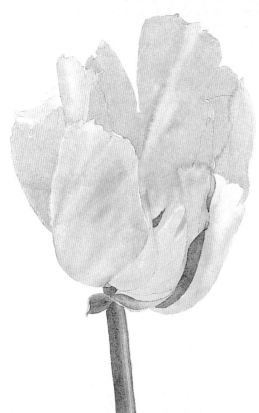

2 APPLY THE PAINT

Using your no. 8 round, apply a light wash of Rose Madder Genuine to the areas that will be red. This wash will be your lightest light. Work quickly and keep the edges soft by using another brush with clean water to moisten the edges of the Rose Madder Genuine to blend into the petals. Don't be concerned about back runs; they add a nice texture to flower petals. Let dry and then mix Aureolin Yellow and Viridian Green to a nice "apple green." Paint the green areas.

3 PAINT THE SHADOW AREAS

When the paint has dried, add light washes of Cobalt Blue to the shadow areas of the petals and stem using a no. 8 round. Wet blend where necessary. Let dry.

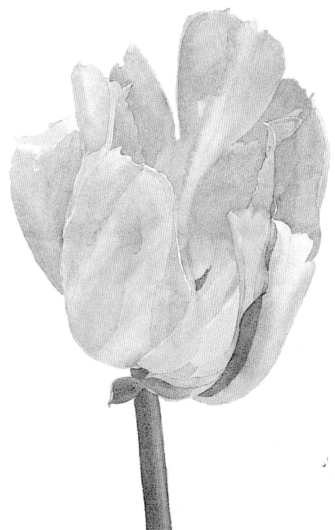

4 START THE BACKGROUND

Now is the time to consider the background. You may decide to leave it the white of the paper, or you could paint in color. I have chosen to paint it blue. Blue represents the sky, and will bring out the glow in the finished flower.

Place paper towels around the edges of the paper to prevent the paint from running back into the painting. Make two puddles of paint, one of Aureolin Yellow and one of a mixture of Aureolin Yellow, Viridian Green and Cobalt Blue. Beginning at the bottom of the painting, brush in the yellow with a no. 8 or 10 round, then randomly dab this area with the mixture of yellow, green and blue, wet blending. This will produce a mottled green. Apply clear water as you move toward the top of the painting to lighten, and then paint down the other side with the clear water. Drop in the mixture on this side to match the opposite side of the painting. Apply Aureolin Yellow to this side first. Let dry. It helps to weight the corners down so that the paper will dry flat.

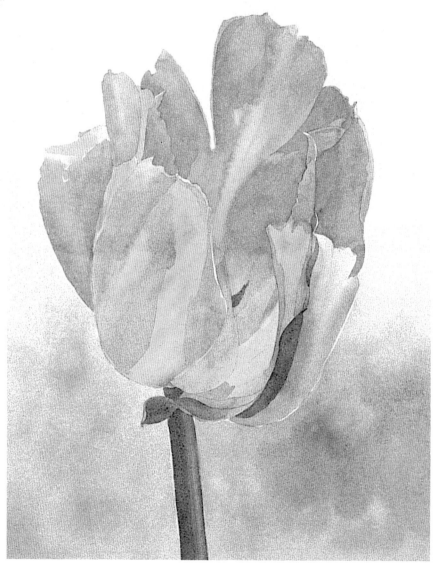

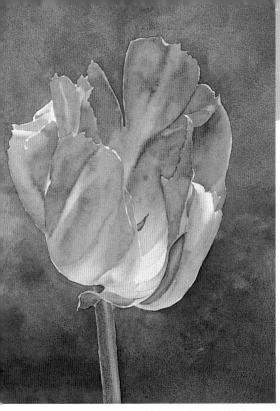

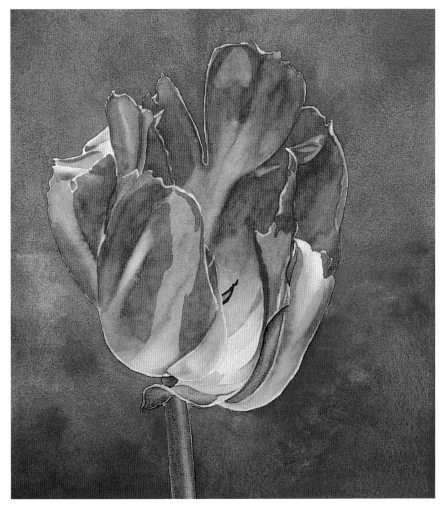

5 DEEPEN THE BACKGROUND

As the background's first layer dries, prepare the blue mixture. In a small container, such as a plastic cup, place three pea-sized dollops of color: Cobalt Blue, Ultramarine Blue and Phthalo Blue. Add about a quarter-inch of water and mix. Adjust the mixture as necessary to get the color you want. You want a rich but watery blue.

Using a no. 8 or 10 round, apply blue paint at the bottom of the picture with a dabbing motion of a stroke. (If you're working on a tilted surface, turn the painting upside down so the color will run toward the top.) Working quickly and keeping the brush loaded, work down one side and then the other. Don't add water; just keep your brush loaded. Let the paint dry, then randomly blot with a damp sponge and a tissue around the lower area for a mottled look. This allows the underpainting to peek through, giving the illusion of organic matter.

6 FINISH THE FLOWER

To finish the flower, deepen the red of the petals with Alizarin Crimson and a no. 8 round. Analyze the painting to see if any areas need additional layers of color. You can alternate layers of Rose Madder Genuine or Alizarin Crimson to achieve exactly the depth of color that you desire, just make sure that you allow each layer to dry thoroughly.

ROSY GLOW | *Watercolor on Arches 300-lb. (640gsm) cold-press* | *23" × 18" (58cm × 46cm)*

MATERIALS LIST

Arches 300-lb. (640gsm) rough-pressed
15" × 23" (38cm × 58cm)

BRUSHES
no. 8 round (sable or synthetic)
no. 10 round (sable or synthetic)

PAINT
Cobalt Blue • New Gamboge • Permanent
Rose • Phthalo Blue • Phthalo Green •
Rose Madder Genuine • Ultramarine Blue
• Viridian Green • Winsor Green

OTHER SUPPLIES
no. 2 pencil • eraser • tracing paper
transfer paper • paper towels

To most novice gardeners, spring bulbs mean crocuses, tulips and daffodils, and certainly no garden should be without them. But there are more than a dozen other kinds of bulbs, each of which include many species and varieties that are as charming as they are easy to grow. The tall, imposing hybrid lily is one example. In my garden, this graceful plant blooms in mid to late spring, and its regal beauty inspires me. Lilies appear in many beautiful colors; this one is a lovely shade of pink. In this demonstration you will capture the grace, color and beauty of its purity.

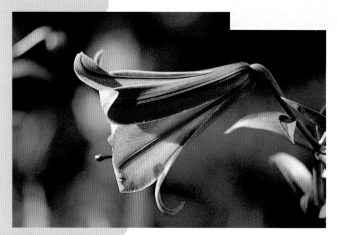

Reference Photo

1 LAY THE FIRST WASH OF COLOR
Draw or transfer the lily onto the paper, then mix up a puddle of New Gamboge. Using a no. 8 round, paint the stem and the areas in the center that have a warm glow. Let dry.

Blown Away Color

You can use a hair dryer to hasten the drying process. If you chose to do this, make sure the paint is not sitting in a puddle (there should be no shine on the paper). Otherwise, the paint will blow all over the painting. I prefer to let the paint dry naturally, allowing it to sink into the fibers of the paper. A dulling of the color can occur with the use of a hair dryer.

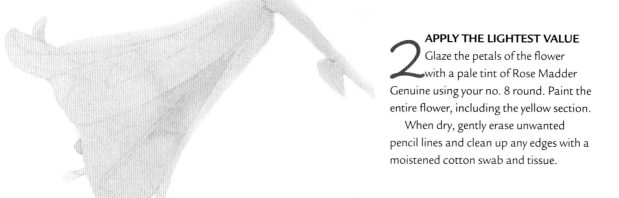

2 APPLY THE LIGHTEST VALUE

Glaze the petals of the flower with a pale tint of Rose Madder Genuine using your no. 8 round. Paint the entire flower, including the yellow section. When dry, gently erase unwanted pencil lines and clean up any edges with a moistened cotton swab and tissue.

3 PAINT THE SHADOWS

Using a no. 8 round, glaze the shadows on the petals and the stem with a pale wash of Cobalt Blue.

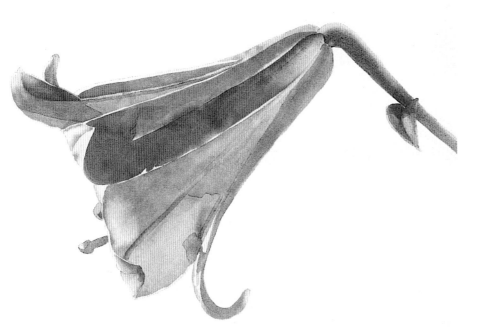

4 BUILD THE COLOR AND FORM

Prepare a medium-value puddle of Permanent Rose. Paint the petals with a no. 8 round, leaving light edges of Rose Madder Genuine as your lightest value. Create a mixture of New Gamboge, Viridian Green and Ultramarine Blue. Using a no. 8 round, paint the stem and leaf.

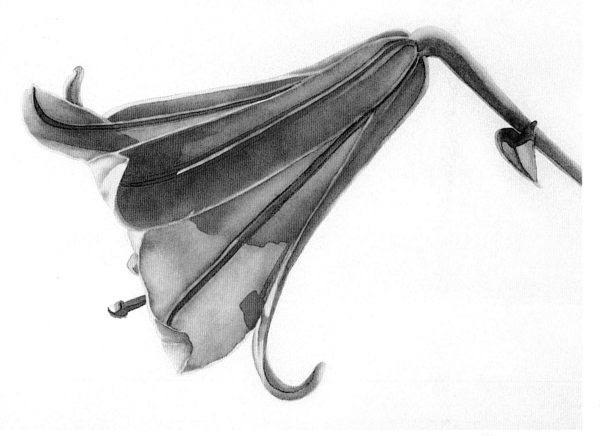

5 DEEPEN THE COLOR WITH LAYERS

Deepen the color where necessary by glazing sections of the petals with Permanent Rose. For the darkest lines in the petals, add a touch of Phthalo Green to the Permanent Rose. Phthalo Green is a staining pigment, so don't add too much. For the darkest dark on the stem, create a mixture of New Gamboge, Winsor Green and Phthalo Blue. Paint the dark areas, then soften the edges with a clean, damp brush, and blend into the lighter areas of the stem and leaf.

Adjust as necessary, lifting areas with a damp brush to lighten and clean up the edges.

SOLILOQUY | *Watercolor on Arches 300-lb. (640gsm) rough-pressed* | *15" × 23" (38cm × 58cm)*

Layering Beauties

One of the beauties of layering or glazing color is that you can apply as many layers as you need to get the desired effect. Just be sure to let each layer dry before applying additional layers.

MATERIALS LIST

Arches 300-lb. (640gsm) rough-pressed
11" × 11" (28cm × 28cm)

BRUSHES
nos. 8 and 10 round (sable or synthetic)
no. 0 round scrubber

PAINT
Alizarin Crimson • Cadmium Orange
• Cadmium Yellow • New Gamboge •
Phthalo Blue • Phthalo Green • Sap Green
• Ultramarine Blue

OTHER SUPPLIES
no. 2 pencil • eraser • tracing paper
transfer paper • paper towels • tissue

No flowers herald springtime with more eloquence than narcissuses. The name daffodil applies primarily to the types with large, trumpet shaped flowers. Like many popular spring bulbs, daffodils (sometimes referred to as jonquils or narcissus) originated in a zone that extends from Portugal eastward across southern Europe and North Africa to the Middle East and Asia Minor, and on to southwestern Russia, Afghanistan and Kashmir.

In this demonstration, you'll be painting the sunshine flower of the spring garden, the golden trumpet daffodil. In order to make the yellow flower really stand out, you'll paint a deep complementary-colored wash as a background.

Reference Photo

1 LAY DOWN THE FIRST WASH
Draw or transfer your flower onto the paper, correct the drawing and erase unwanted pencil lines.

Mix a fully saturated puddle of Cadmium Yellow. With a no. 8 round, paint the entire flower and stem. Let dry.

Keep it Clean

Keep an extra brush at hand to use for softening and blending edges, and make sure that your water is clean.

2 PAINT THE BACKGROUND

Mix a good-sized amount of pigment to paint the background. You want a deep, purplish royal blue, so create the mixture using Ultramarine Blue, Phthalo Blue and Alizarin Crimson.

Place paper towels under your paper to prevent backruns. Fully load a no. 10 round with color. Begin painting at the bottom of the image and work quickly up and around to the opposite side. Keep the edges wet, and the brush loaded. Let dry.

Dab a damp no. 8 round against the edge of the blue to soften the edge, and blot with a tissue. Do this around the entire flower.

Color in a Jar

If you mix up your color in a 4-ounce (125 ml) jar with a lid, you can save the extra paint for touch-ups or another layer, maybe even for use in a future painting.

3 STRENGTHEN THE FLOWER

Paint the center of the flower where the light is warm with Cadmium Orange using a no. 8 round. With the same color and brush, paint the other warm areas on the flower, wet blending edges as necessary.

Create a deep blue-green mixture using New Gamboge, Phthalo Green and Phthalo Blue. Run a brushful down the shadow side of the stem. Quickly run a clean no. 8 round loaded with clean water down the light side of the stem, wet blending as you go. If too much dark color creeps over, wring out your brush and use it to lift the excess paint. You might have to repeat this several times. Let dry.

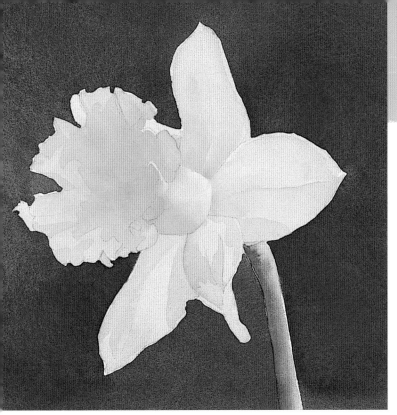

4 PAINT THE SHADOWS

Add a little Sap Green to Cadmium Yellow. Using a no. 8 round, lay a light wash of this green over the shadow areas. For the shadow side of the stem, create a darker mixture of Phthalo Green and Phthalo Blue. Lay a wash of this color down the shadow side of the stem. Let dry.

Gently Erase

If you need to lighten a large area, gently rub the area with an eraser. The eraser will lift some color, but it may also damage the paper, so make sure that your painting is dry and completely finished.

5 MODEL THE FORM

Create a rich, saturated yellow by mixing Cadmium Yellow with a small amount of water. Use a no. 8 round to paint the darker areas of the petals and center, using your previous shadow layer as a guide. Blend edges as necessary. Let dry. Warm up the center of the flower where the sun shines through the petals using Rose Madder Genuine and a no. 8 round. Continue modeling the form and strengthening the shadows using Cadmium Orange. When everything is dry, lift out any of the lights that you may have lost using your little lifting brush. Load your no. 0 scrubber with water and gently scrub any areas that need to be lightened.

GOLDEN GIRL
Watercolor on Arches 300-lb. (640gsm) rough-pressed 11" × 11" (28cm × 28cm)

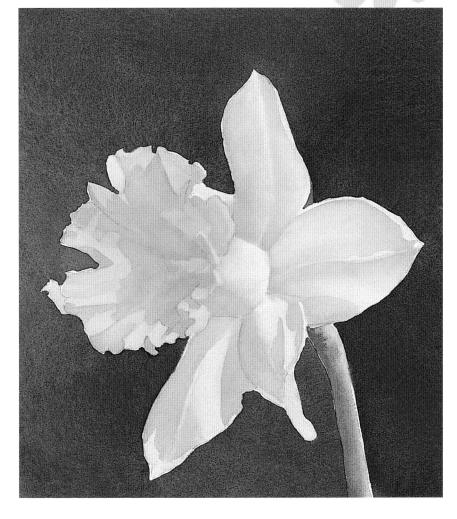

MATERIALS LIST

Arches 300-lb. (640gsm) rough-pressed
15" × 16½" (38cm × 42cm)

PAINT
Aureolin Yellow • Cadmium Orange •
Cerulean Blue • Cobalt Blue • Phthalo
Blue • Rose Madder Genuine • Ultrama-
rine Blue • Viridian Green

BRUSHES
nos. 8 and 10 round sable or synthetic
no. 0 scrubber

OTHER SUPPLIES
tracing paper • graphite transfer paper
no. 2 pencil • eraser • paper towels

The lovely little spring-flowering Dutch iris hybrid is a descendant of the more than 200 kinds of wild iris that grow in various parts of the world. The Dutch iris hybrids are obtained by crossing the Spanish iris and several other species, and come in a variety of colors including bi-color mixtures.

This pretty little Dutch iris blooms in my garden each spring and hold its own among the camellias and azaleas that try to outshine it. In this demonstration, you'll be using the white of the paper as your lightest light, and painting shadows to reveal the form of the flower. You'll be glazing and layering color to build up the soft color of the petals and putting in a granulating background wash to set off this glowing gem.

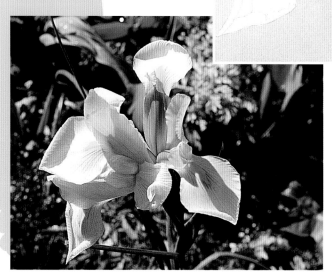

Reference Photo

1 LAY DOWN THE FIRST WASH
Transfer your drawing to your water-
color paper. Correct the drawing, and erase unwanted pencil lines.

For the first wash, mix a large puddle of Aureolin Yellow to a medium satura-tion. Using a no. 8 round, paint the lower area of the paper, including the leaves and stems. Wet blend with clear water, brush-ing all the way to the top of the paper on each side. The heavily saturated color on the bottom should gradually lighten as it moves up, until it finally reaches the color-less top section.

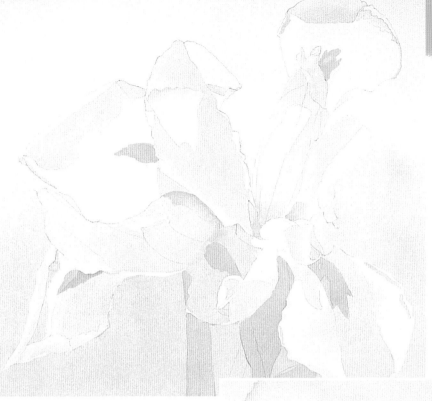

2 PAINT THE SHADOW AREAS

For the shadow areas, mix Aureolin Yellow and Rose Madder Genuine to create orange, then add Cobalt Blue until you have a pinkish gray color. Test this on a scrap of watercolor paper. You want a tint of gray. Paint the shadow areas using a no. 8 round. At this stage of the painting, the shadow wash will appear dark next to the white of your paper.

3 BEGIN THE BACKGROUND

For the background, create a large puddle of Rose Madder Genuine. Load a no. 8 round and begin painting at the bottom of the paper, working the paint upward. At the midpoint, load your brush with clear water and continue up the paper. Using the dampened brush, paint down the opposite side of the paper until you reach the midpoint. Load the no. 8 round with Rose Madder Genuine and continue down to the bottom of the paper. Let dry.

Correct "Blooms"

If your wash "blooms" like mine did in the upper left side, let the paint dry, then take a damp brush or little damp sponge and dab along the edges and blot with a tissue.

Is It Done Yet?

When is your painting finished? For me, it's
when I can't find another place to apply a
brushful of color. It doesn't matter how long it
takes to finish a painting. It's finished when it
pleases your eye.

4 CONTINUE GLAZING COLORS

With a no. 8 round, paint Cadmium Orange over the yellow areas. Create a green mixture that's slightly on the blue side with Aureolin Yellow, Viridian Green and Cobalt Blue. Use this green with a no. 8 round to paint the stem and leaves. Create a violet by mixing Rose Madder Genuine and Cobalt Blue. Use this with a no. 8 round to paint the violet areas in the petals. Keep another brush ready with clean water to soften any hard edges. Drop a little of the violet mixture into shadow areas.

5 PAINT BACKGROUND AND GLAZE

For the background, mix a good size puddle of a "sky blue" in a small jar or a plastic cup. Mix Cobalt Blue, Cerulean Blue and Ultramarine Blue—about a pea-sized dollop of each—with about 1 inch (3cm) of water. Mix well. Test on a piece of scrap paper. Because Cerulean Blue is an opaque pigment, this mixture will granulate and give a nice sky effect. With a no. 10 round, paint the entire background with the blue mix. Let dry.

To finish, glaze violet petals with Rose Madder Genuine using your no. 8 round. Brighten up the yellow with Cadmium Orange. Paint the shadow areas of the leaves Phthalo Blue. Strengthen some of the flower's shadow areas with a light wash of Cobalt Blue. If the darker areas of the petals need strengthening, use your original mix of violet, and glaze as necessary to achieve the result that you are looking for. When everything is dry, evaluate your work. Lift with a small stiff bristle brush if necessary.

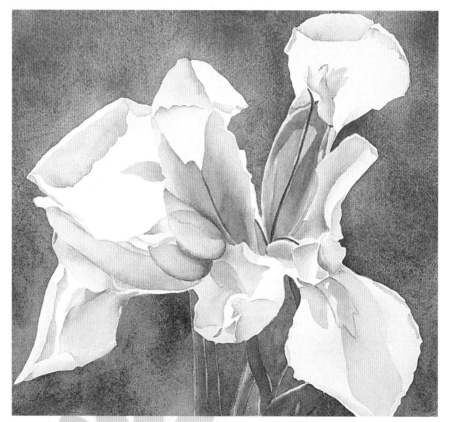

DUTCH GEM
*Watercolor on Arches 300-lb. (640gsm) rough-pressed
15" × 17" (38cm ×43cm)*

How Long Does It Take?

When asked during a workshop, "How long
did this painting take you to paint?," my
mentor Robert E. Wood replied, "25 years."
Then he looked at his watch and said, "And
45 minutes."

MATERIALS LIST

Arches 300-lb. (640gsm) cold-pressed
15" × 18" (38cm × 46cm)

BRUSHES
no. 8 round (sable or synthetic)
no. 0 round scrubber

PAINT
Aureolin Yellow • Cadmium Orange •
Cobalt Blue • New Gamboge • Permanent
Rose • Phthalo Blue • Phthalo Green •
Rose Madder Genuine • Ultramarine Blue
• Viridian Green

OTHER SUPPLIES
tracing paper • graphite transfer paper
no. 2 pencil • eraser • paper towels

Many flowering shrubs that adorn American gardens today look so much at home, it's difficult to realize they were originally brought back from the Far East by professional plant hunters who completed long and often hazardous journeys to find them. Plant hunting probably started 5,000 years ago when the Pharaohs of Egypt sent ships down the Red Sea in search of cinnamon and cassia. Its golden age, however, began in the 18th century when European naturalists visited China and stumbled upon then-exotic species such as honeysuckle and azalea. The botanist-explorers who followed probed deep into China, dubbing it "the central flowering land." The camellia is native to eastern and southern Asia. There are over 3,000 named kinds, and they range in color, size and form. Camellia breeding is still in its infancy, and what is yet to come stirs the imagination—blue and purple camellias, yellow and orange camellias, fragrant camellias, all are possible.

In this demonstration you'll learn how to approach painting a complex form. We'll be concentrating on the flower, so a background is not included. The trick is to work in relatively small areas, one petal at a time.

Reference Photo

1 LAY DOWN THE FIRST WASH
Draw or transfer your flower onto the watercolor paper, correct your drawing and erase unwanted pencil lines. Using a no. 8 round and Aureolin Yellow, paint the center of the flower and the stamen area, then take the same mix and paint the leaves. Let dry.

MATERIALS LIST

Arches 300-lb. (640gsm) rough-pressed
15" × 22" (38cm × 56cm)

BRUSHES
no. 0 scrubber
nos. 6, 8, 10 round (sable or synthetic)
1-inch (25mm) flat (sable or synthetic)

PAINT
Alizarin Crimson • Cadmium Orange •
New Gamboge • Phthalo Blue • Rose
Madder Genuine • Scarlet Lake • Ultramarine Blue • Viridian Green

OTHER SUPPLIES
no. 2 pencil • eraser • tracing paper •
graphite transfer paper • paper towels •
tissue • razor blade or craft knife

When the tulips and daffodils have faded and summer annuals still are seedlings, the alluring hairy-leaved Oriental poppy rises to perform spectacularly. For centuries, only the bright scarlet and black poppy was known, and it became one of the most fabled floral symbols of all time. Today, however, poppies come in various shades of spectacular colors, ranging from brilliant orange to salmon, from pure white to the traditional scarlet to pink.

This demonstration will show you how to begin with a warm underpainting and build the intensity of the color through layering one glaze on top of the other.

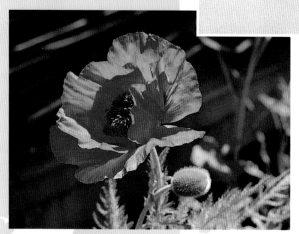

Reference Photo

1 LAY DOWN THE FIRST WASH
Transfer your flower onto your watercolor paper, correct your drawing and erase any unwanted pencil lines.

Place paper towels under your paper to prevent backruns. Using your largest brush, paint the entire sheet with a medium value Cadmium Orange. Weigh down the corners of the paper in order for it to dry flat.

Warm Undertones

In watercolor, Cadmium Orange dries to more of a yellow. By toning the entire sheet, you get rid of the white paper and have a nice warm underpainting to begin your application of layers of color.

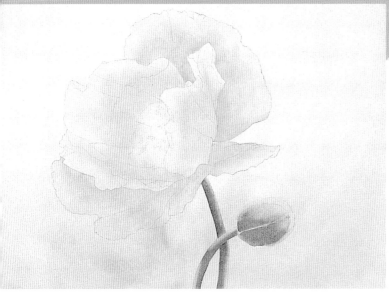

2 BEGIN PAINTING THE PETALS AND STEM

Load a no. 8 round with Cadmium Orange. Begin painting at the center of the flower, moving out toward the tips of the petals, just using clear water as you get near the edges. For the stems, create a medium-value green mixture with New Gamboge, Viridian Green and Ultramarine Blue. Paint the stems, wet blending the edges.

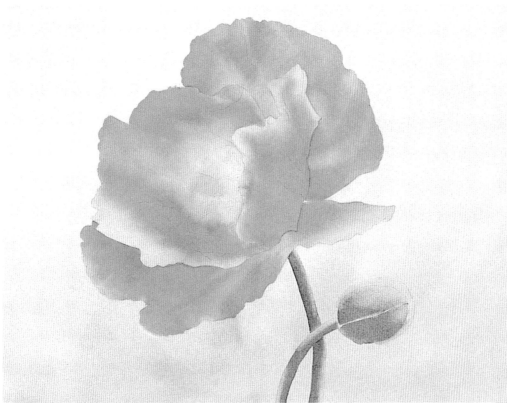

3 CONTINUE PAINTING THE PETALS

With a no. 8 round and a medium-value Permanent Rose, paint the petals. Starting at the top and bringing the color down toward the center. Use clear water to wet blend into the centers and edges so that your paint stays wet as you finish.

Softening Edges

You might get hard lines where wet paints overlap drier paint. Wait until the flower is dry and then take a damp brush and dab at the lines and blot with tissue. Let dry.

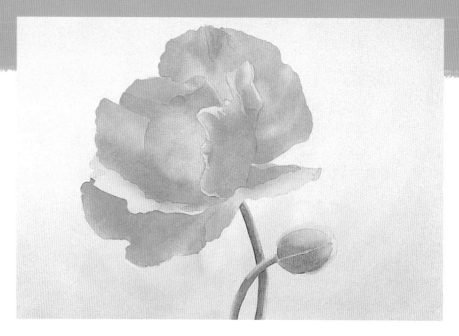

4 PAINT THE SHADOWS

Paint a light wash of Phthalo Blue over the shadowed areas on the petals with a no. 8 round. Bring the shadow mix down into the stem.

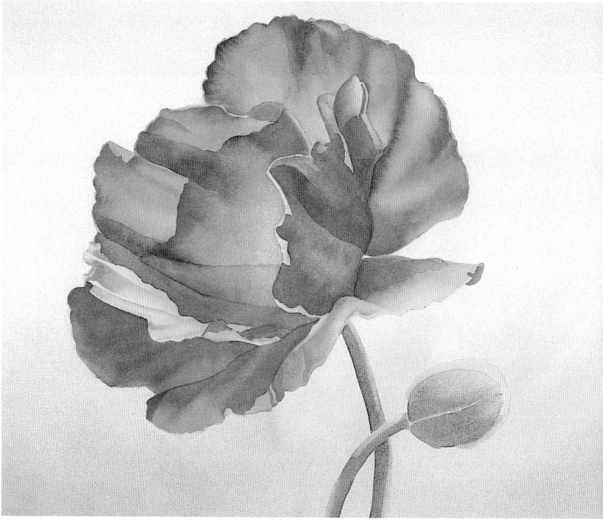

5 MODEL THE FORM

Model the form on the petals using a medium-value of Scarlet Lake and a no. 8 round, wet blending as needed. Continue glazing with Scarlet Lake until you feel you've achieved the desired intensity of color and weight of the flower. This may require several layers of color. Let dry.

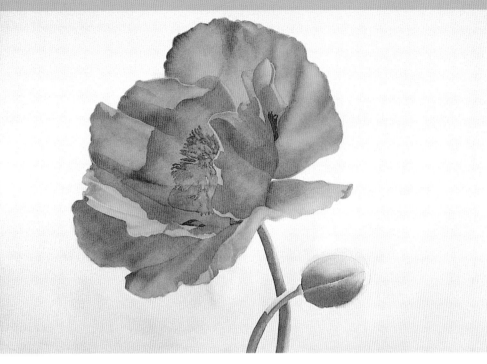

6 **STRENGTHEN THE COLOR**
Glaze the entire flower with a medium-value tint of Rose Madder Genuine, using a no. 8 round. Let this dry. For the dark centers of the poppy, create a mixture of Alizarin Crimson and Phthalo Green that "reads" as black. Don't let it get too watery; this is where you want a deep dark. Wetting the edges will create a natural look and allow the underlying color to peek through. Use a no. 6 round to paint the stems with a mix of Cadmium Yellow, Phthalo Green and Phthalo Blue. Let dry.

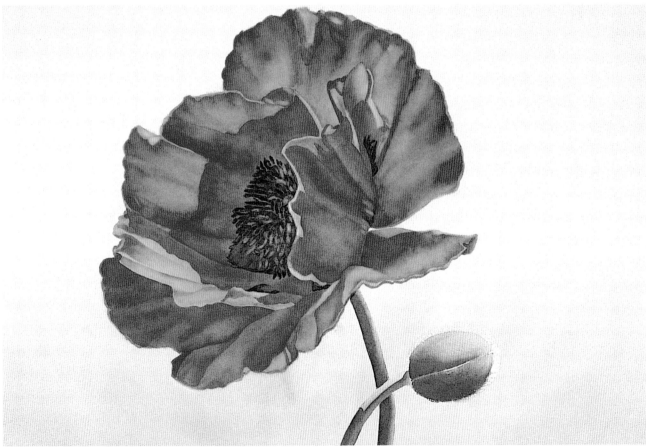

7 **ADD THE FINISHING TOUCHES**
Evaluate your painting. Do you need to add more layers of Scarlet Lake anywhere? When you're satisfied, deepen the black centers using the Alizarin Crimson and Phthalo Green mixture and a no. 6 round. Use Phthalo Blue to add a shadow to the stem. With a craft knife or single-edged razor blade, pick out the light hairy parts on the bud. With no. 0 scrubber, lift out the excess pigments to bring back the light areas.

PRINCE OF ORANGE | *Watercolor on Arches 300-lb. (640gsm) rough-pressed* | *15" × 22" (38cm × 56cm)*

MATERIALS LIST

Arches 300-lb. (640gsm) cold-pressed 15" × 17" (38cm × 43cm)

PAINT
Aureolin Yellow • Cadmium Orange • Cobalt Blue • Manganese Violet (Daniel Smith) • New Gamboge • Permanent Rose • Turquoise Blue (Holbein) • Viridian Green

BRUSHES
nos. 8, 10 round (sable or synthetic)

OTHER SUPPLIES
tracing paper • graphite transfer paper • no. 2 pencil • eraser • paper towels • cotton swabs

The lotus is the most admired of all aquatic plants with its elegant bearing, graceful flowers and traditional heritage.

The lotus is intimately associated with the creation of the world, purity and beauty. It is one of the best-known symbols in Asia, especially China and India, and was also very important to the Egyptians and ancient Greeks.

The plant plays a key role in Indian mythology. For Buddhists, the lotus is a symbol of purity, for its flower rises immaculately from its muddy bed. In China, it symbolizes the Chinese model of the "superior man."

In this demonstration you will paint in a direct manner treating your subject semi-abstractly. You will be using washes, glazes and layering to render the graceful lotus flower. In painting the background washes, you will treat the leaves in a simplistic abstract style. You will learn that you don't have to paint every vein in a leaf or detail in a flower to arrive at a satisfactory conclusion.

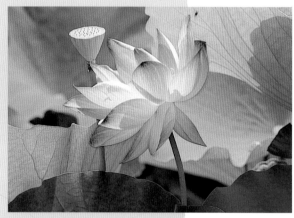

Reference Photo

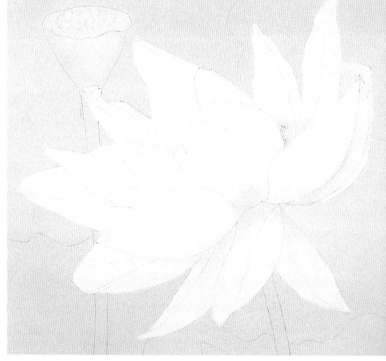

1 LAY THE FIRST WASH OF COLOR

Transfer your composition to your watercolor paper. Correct your drawing and erase any unwanted pencil lines.

Using a no. 8 round, paint the warm center of the flower Aureolin Yellow, lightening the wash with clear water as you move along the petals. Place paper towels under your paper, then paint the background Aureolin Yellow using a no. 10 round. Let everything dry.

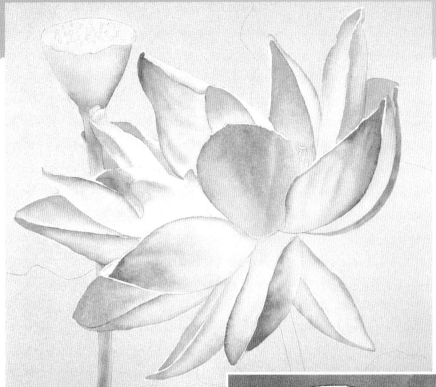

PAINT THE PETALS

2 Starting at the outer edges, paint the petals Permanent Rose with a no. 8 round. You want to preserve a lot of the white of the paper, so take another brush loaded with clear water and wet blend the color wash with water pulling it down to create a very light, graded tint of pink. Paint the same tint of color on the seed pod.

PAINT THE BACKGROUND FOLIAGE

3 Using a no. 8 round brush, glaze the seed pod and stems with Cobalt Blue. Paint the stamens with Cadmium Orange using a no. 8 round brush. Evaluate the flower. Warm up areas of the petals with Cadmium Orange if needed. For the green leaves in the background, use a mix of New Gamboge, Viridian Green and Cobalt Blue. Vary the mixture by adding more Cobalt Blue mixture. Paint the blue-green areas with Turquoise Blue. For the leaf in the upper left, add a little Phthalo Blue to the Turquoise Blue and apply using a no. 8 round brush.

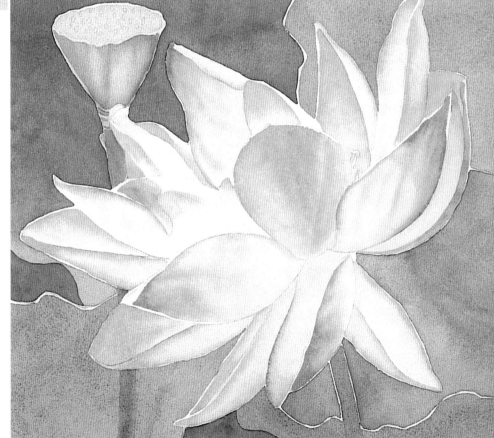

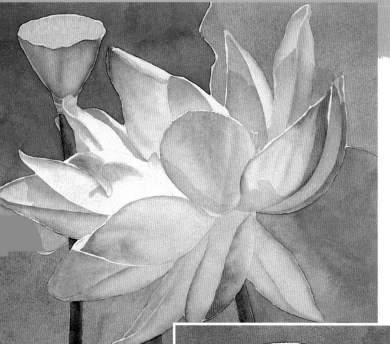

PAINT THE SHADOWS

For the shadows, you want a "barely there" tint of Manganese Violet. Using a no. 8 round brush, paint the shadows on the flower and stems.

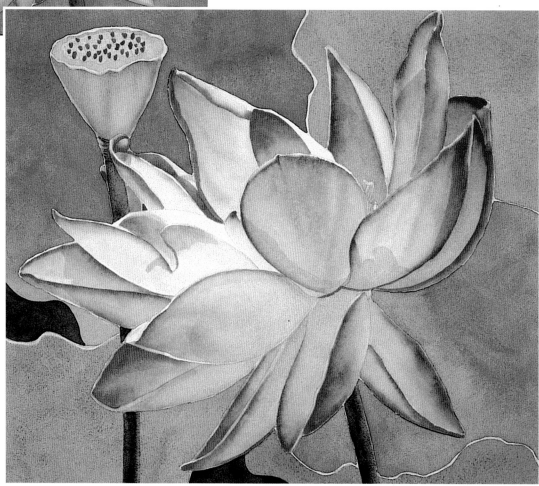

ADD ACCENT COLORS

For the darker accent colors on the petals, stem and background, lay down a glaze of strongly saturated Permanent Rose with a no. 8 round. Continue glazing until the result pleases your eye. Paint the red seeds on the seed pod using Permanent Rose. Let dry and clean up edges with a cotton swab. Lift out light areas with a no. 0 scrubber.

LES NYMPHEA | *Watercolor on Arches 300-lb. (640gsm) cold-pressed* | *15" × 17" (38cm × 43cm)*

MATERIALS LIST

Arches 300-lb. (640gsm) cold-pressed
15" × 22" (38cm × 56cm)

BRUSHES
nos. 8, 10 round (sable or synthetic)

PAINT
Aureolin Yellow • Cadmium Yellow • Cadmium Orange • Cobalt Blue • Manganese Violet • New Gamboge • Permanent Green • Phthalo Blue • Phthalo Green • Rose Madder Genuine • Ultramarine Violet (Daniel Smith) • Viridian Green

OTHER SUPPLIES
tracing paper • graphite transfer paper • no. 2 pencil • eraser • paper towels • tissue

The morning glory is an ornamental vine with flowers that open in the morning, but close by the afternoon (hence the name). You may be used to seeing the lovely bright blue flowers, but morning glories come in a multitude of colors: shades of violet, rosy red, scarlet and even tricolor. Funnel-shaped to bell-shaped, single-colored or striped, the variety of morning glories is simply stunning. My reference slide shows a red-violet flower. Pretty, but I wanted to paint a bluer flower, so I changed the color. You're the artist; don't be a slave to your reference material.

In this demonstration, you'll learn about negative painting (essentially, painting the areas around something). Here, you'll use negative painting to glaze deeper color in the background while protecting lighter colors.

Reference Photo

1 PAINT THE BACKGROUND
Transfer the drawing to the paper. Mix a good-sized puddle of Aureolin Yellow, Permanent Green and Cobalt Blue. Begin at the top edge of the drawing. Wet this little area to soften the edge, then use a no. 10 round to paint down the right side of the painting, around the bottom, then up the left side and back to the beginning. Tint the flower's center Aureolin Yellow with a no. 8 round.

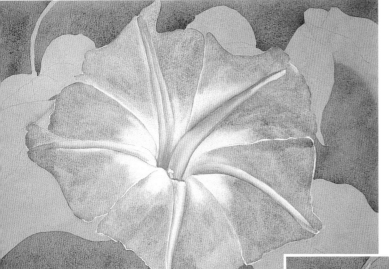

2 PAINT LEAVES WITH NEGATIVE PAINTING

Paint the stamen Cadmium Orange using a no. 8 round. For the petals, create a mixture of Ultramarine Violet and Cobalt Blue. Paint each petal section individually, beginning at the top and lightening the color as you move toward the center. Add a little Rose Madder Genuine to the flower's center, and to the pinker folds between the petal sections. For the background, create a mixture of New Gamboge, Viridian Green and Ultramarine Blue. Using a no. 10 round, paint around the lightest lights (negative painting) to define the leaf shapes. Let dry.

3 MODEL THE FORM

Create a mixture of Ultramarine Violet and Cobalt Blue that is slightly darker than the blue mixture in the previous step. Because you want to get the color right the first time (Ultramarine Violet lifts easily), test the mixture on a scrap paper first. Using a no. 8 round and the deep blue mixture, model the form of the petals. Use a clean, damp brush to soften the edges.

Add a little more Rose Madder Genuine to the flower's center and soften the edges with clear water. Create a mixture of Cadmium Yellow, Phthalo Green and Phthalo Blue for the leaves. Mix the Cadmium Yellow and Phthalo Green to a nice yellow-green, then add Cobalt Blue a little at a time until you reach the right color. Using a no. 8 round and this mixture, model the form of the leaves. Keep the leaves simple with little detail. Let dry.

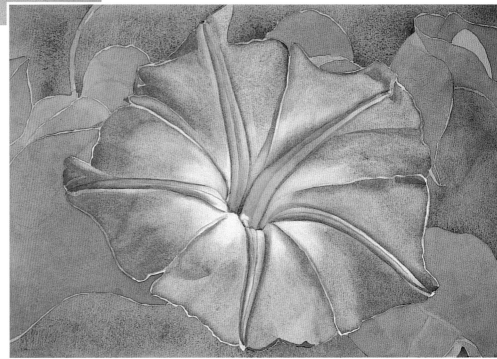

Enjoy the Negative Painting

Have fun with this step! Use your intuition on the placement and painting of the leaf shapes. Don't worry about backruns; they add interest.

Ultramarine Violet

Ultramarine Violet lifts easily. Try to get your first wash of blue as close as possible to the color you want. You don't want to paint over the Ultramarine Violet too many times or the color will lift.

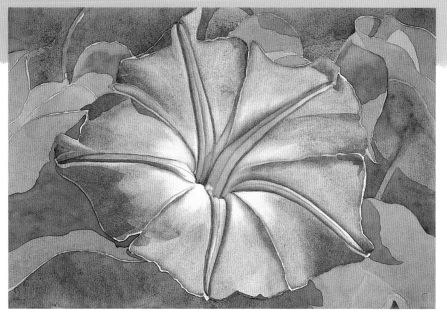

4 PAINT THE SHADOWS

For the shadows on the petals, create a medium-value mixture of Ultramarine Violet and Cobalt Blue. Paint the shadows using a no. 8 round brush. Paint the shadow area in the center with a light tint of Manganese Violet with a no. 8 round brush, softening edges with clear water. For the shadows on the leaves, use your no. 8 round and Phthalo Blue. With the Phthalo Blue, paint around the leaf shapes in the background. Let dry.

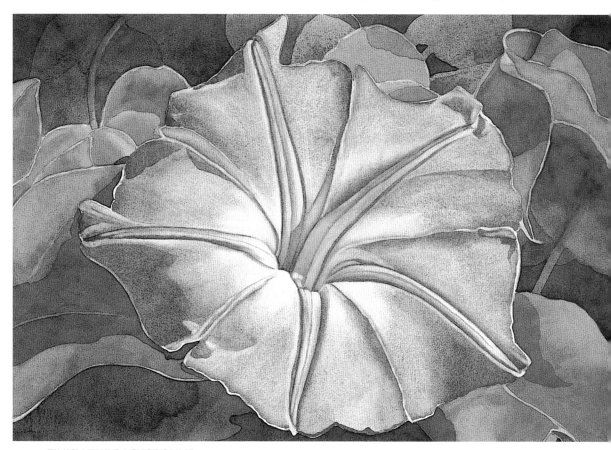

5 FINISH THE BACKGROUND

Lightly draw in more leaf shapes in the background using a no. 2 pencil. Using Phthalo Blue and no. 8 round, paint around these shapes (negative painting). Create a mixture of Cadmium Yellow, Permanent Green and Phthalo Blue. Use this mixture and a no. 8 round to reinforce the darks in the leaves. Layer Phthalo Blue around and over leaf shapes in the background to bring some forward and push others back.

Continue glazing the background with Phthalo Blue until the result pleases your eye. Bring back any lost lights in the petals and leaves with a cotton swab or a no. 0 scrubber.

GLORY | *Watercolor on Arches 300-lb. (640gsm) cold-pressed* | *15" × 22" (38cm × 56cm)*

DEMONSTRATION *Rose*

MATERIALS LIST

Arches 300-lb. (640gsm) cold-pressed 15" × 20" (38cm × 51cm)

BRUSHES
1-inch (25mm) flat
nos. 8 and 10 round (synthetic or sable)

PAINT
Cadmium Orange • Cerulean Blue • Cobalt Blue • New Gamboge • Permanent Rose • Rose Madder Genuine • Sap Green • Ultramarine Blue • Viridian Green

OTHER SUPPLIES
no. 2 pencil • eraser • tracing paper • graphite paper • paper towels • tissue

Since ancient times, the rose has been cherished for its beauty and its fragrance. Today, the rose is the most popular and widely cultivated garden flower in the world. The genus contains some one hundred species. Some are cultivated in their natural form, but most of the more than 20,000 cultivars are the result of careful hybridization and selection from a few species. Several hundred new contemporary rose cultivars are introduced each year.

In this demonstration you'll learn to tone your paper with an overall yellow wash, followed by an overall red layer to prepare your painting for the final layer of blue in the background.

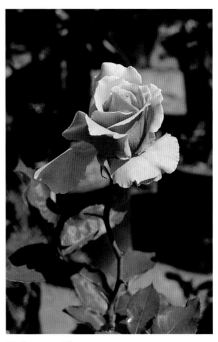

Reference Photo

1 LAY THE FIRST WASHES AND MODEL THE FORM
Transfer your drawing to your paper. Beginning at the bottom of the sheet, brush in the New Gamboge with a 1-inch (25mm) flat. Keep the color deeper at the bottom of the paper and fade out with clear water as you reach the top. Let dry, weighting down the corners so that the sheet will dry flat. Model the form of the rose with a medium-value Cadmium Orange and a no. 8 round. Begin at the center of the flower, bringing the color out to the petal tips with clear water. Paint the stem using a no. 8 round and a mixture of New Gamboge, Viridian Green and Cobalt Blue.

2 PAINT THE PETALS' SHADOWS

Create a light-value mixture of Permanent Rose and a touch of Sap Green, keeping the mixture more red. Paint the shadows on the petals using a no. 8 round. Let dry.

3 LAY A WASH OF ROSE MADDER GENUINE

To clean up the edges, soften them with a cotton swab or damp brush, then blot with a tissue. Paint a tint of Rose Madder Genuine over the entire sheet using a 1-inch (25mm) flat brush. This will soften the image and prepare the background for the blue layer. Let dry.

4 CONTINUE MODELING THE FORM

Continue to model the form of the petals, using Rose Madder Genuine and a no. 8 round brush. Create a green mixture of New Gamboge, Viridian Green and Cobalt Blue. With a no. 8 round brush and this mixture, paint the stem, saving the light areas. Let dry.

Absorb the Backruns

When painting large wet backgrounds, it's helpful to place paper towels under and around all edges of your paper, leaving a good margin of the paper towel exposed. This serves to absorb the excess moisture and prevents the pigment from running back into your painting.

5 PAINT THE BACKGROUND

For the background blue, create a sky blue mixture of Cobalt Blue, Cerulean Blue and Ultramarine Blue in a plastic cup. Place paper towels under your paper to prevent backruns. Paint the background using a no. 10 round. Keep your edges wet and your brush loaded with color.

6 FINISH THE PAINTING

Evaluate your painting and observe where you need deeper color. Apply Rose Madder Genuine where needed. Create a mixture of New Gamboge, Viridian Green and Cobalt Blue, keeping the mixture on the blue side, then paint the stems.

CAMELOT | *Watercolor on Arches 300-lb. (640gsm) cold-pressed* | *15" × 20" (38cm × 51cm)*

MATERIALS LIST

Arches 300-lb. (640gsm) rough-pressed
22" × 18" (56cm × 46cm)

BRUSHES

nos. 6, 8 and 10 round (sable or synthetic)
1-inch (25mm) flat
no. 6 round synthetic for applying masking fluid

PAINT

Alizarin Crimson • Cadmium Orange • Cadmium Red • Cerulean Blue • Cobalt Blue • Neutral Tint • New Gamboge • Permanent Magenta • Phthalo Blue • Phthalo Green • Rose Madder Genuine • Scarlet Lake • Ultramarine Blue • Viridian Green • Yellow Ochre

OTHER SUPPLIES

tracing paper • graphite transfer paper • no. 2 pencil eraser • small sponge • masking fluid • gum rubber pickup • liquid soap • paper towels • tissue

Zinnias are a favorite for the summer and early fall garden. They are heat lovers and come in a variety of colors that attract bees and butterflies.

In this painting of a colorful zinnia and butterfly, you'll learn how to introduce an insect into your floral work (a second subject into the painting), and the process of layering one pure color pigment on top of another to achieve the intense color your painting requires. This method will allow you great control. You'll also learn how to paint a background using a simple wash and a glazing technique that will enhance your subject.

Reference Photo

Reference Photo

Masking Fluid

Masking fluid is a liquid latex that can be applied to an area of your painting to protect it. When the masking fluid dries, it bonds with the paper to prevent paint from reaching that area. You can paint over the area as you please, then peel up the masking fluid. Immediately after applying masking fluid, wash your brush with soap. Allowing the masking fluid to dry in the brush will ruin the bristles. It's a good idea to use inexpensive or old brushes for this job.

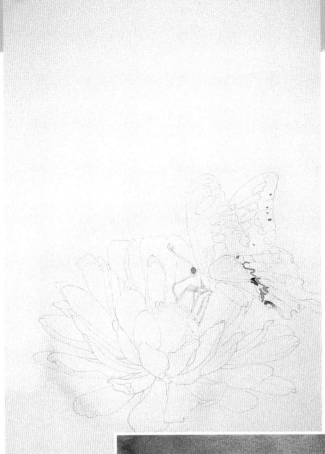

1 LAY DOWN THE FIRST COLORS

Project or draw your flower on tracing paper, using the grid for placement. On another sheet of tracing paper, draw the outline of your butterfly. Place the insect drawing on top of your flower tracing and adjust the scale and placement. When you are satisfied, transfer your drawing to the watercolor paper.

Using a no. 6 round, paint the accents on the wings and eyes Phthalo Blue. Create an orange mixture with New Gamboge and Cadmium Red, and paint the orange accents on the wing with a no. 6 round. Let dry. Dip your no. 6 synthetic round brush into the masking fluid, then carefully cover the antennae, legs and proboscis (the long hollow tube that butterflies use to sip nectar), as well as the blue and orange areas of the wing.

Place paper towels under your paper to prevent backruns. Load your largest brush with New Gamboge and, beginning at the bottom, lay a wash over the entire paper. As you reach the top of the flower, load your brush with clear water and continue. Let dry.

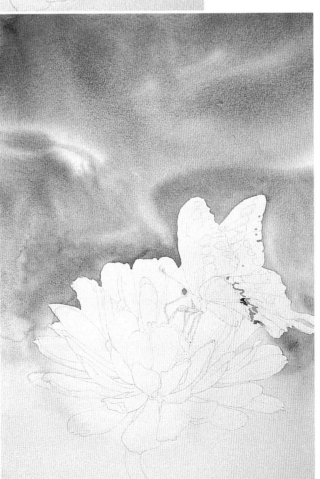

2 PAINT THE SKY

Using the largest brush, wet the sky background area with clean water using your largest brush. Mix up a generous puddle of Cobalt Blue, Cerulean Blue and Ultramarine Blue for a nice "sky blue" color. Keep a small, damp sponge handy and a box of tissue to gently form cloud shapes and to blot up any excess pigment while the paint is wet. Load the largest brush with the blue. Beginning at the top left corner, loosely paint the background, allowing some tinted white of the paper to show as wispy clouds. As you move toward the bottom of the paper, lighten the blue wash with clear water. Don't worry about backruns; they add interest.

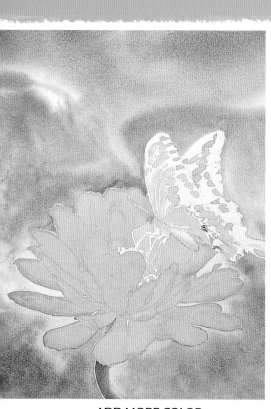

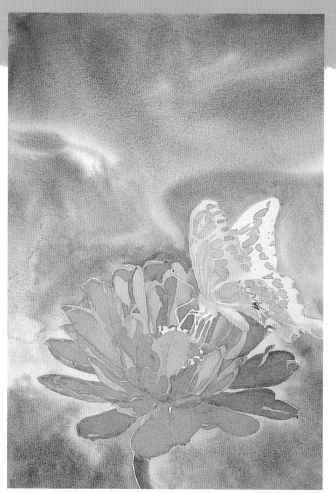

3 ADD MORE COLOR

Remove masking fluid. Clean up the edges of the butterfly and zinnia with a damp brush and tissue. Load the no. 8 round with a light tint of Scarlet Lake and paint the flower petals. This color will be your lightest light. Paint the yellow areas on the butterfly and the center of the flower with New Gamboge. Create a green mixture of New Gamboge, Viridian Green and Cobalt Blue. Paint the stem. Add some of this green to the lower background, wet blending any edges. Let dry.

4 PAINT THE SHADOWS

Paint the shadows on the zinnia Permanent Magenta using a no. 8 round. For the butterfly wing in shadow, mix Neutral Tint with a little Rose Madder Genuine, a "barely there" color.

Neutral Tint will lower the value without changing the hue of the color. Be careful—this is a staining pigment; just a tint of it will do the job.

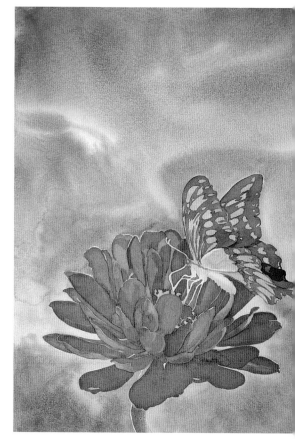

5 ADD THE DARKER VALUES

Mix a medium value of Cadmium Red and paint the petals one at a time. Skip around so that the wet colors don't touch. For the dark colors on the butterfly wings, mix Alizarin Crimson and Phthalo Green to a deep, transparent dark. You can adjust the mixture so it's a little more red on the rear wing and a little more green (which makes it darker, almost black), on the front wing. Let dry.

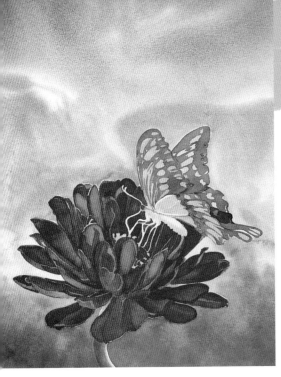

6 GLAZE AND CHARGE

Glaze a medium value Alizarin Crimson over all the petals. Let this dry, then build up the darks using Alizarin Crimson. This may take several layers of color. Using a medium value Yellow Ochre, paint any yellow areas on the butterfly that are shadowed. Glaze the shadowed side of the flower stem Phthalo Blue. Wet the green edge of the background where it meets with the sky, then create a green mixture using New Gamboge, Phthalo Green and Phthalo Blue. Paint random patches of this color into the green background. Charge some of these areas with Phthalo Blue and some with Phthalo Green. Let dry.

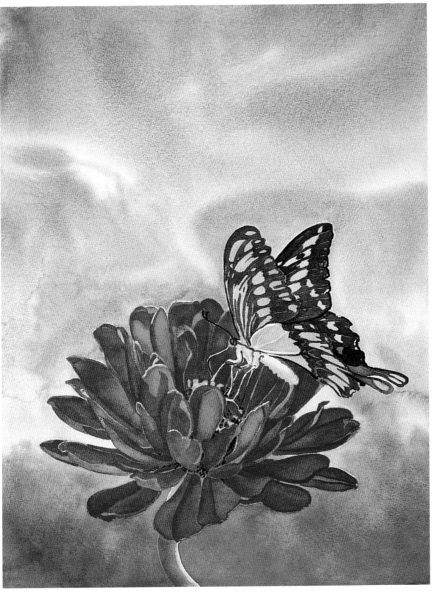

7 LIGHTEN AND DARKEN AS NEEDED

Deepen the darks on the butterfly wings and legs with Alizarin Crimson and Phthalo Green. Use the same mixture to paint the black areas in the flower's center. Dab a little Cadmium Orange on the yellows in the center. Look over your painting and decide which areas should be lightened or darkened. You can lighten your reds by going over the area with a damp brush and then blot with a tissue. Lift as necessary with your little lifting brush. A craft knife or single-edged razor blade can pick out little sparkling highlights as needed. Clean the edges using a damp brush and blot with a tissue.

No two butterflies are alike, so don't be worried if your butterfly is not *exactly* like your model. It will be recognized as a butterfly and that's all that's important.

BREAKFAST AT ZINNIA'S
Watercolor on Arches 300-lb. (640gsm) rough-pressed
21" × 18" (53cm × 46cm)

MATERIALS LIST

Arches 300-lb. (640gsm) rough-pressed
17" × 15" (43cm × 38cm)

BRUSHES

1-inch (25mm) flat brush
nos. 6, 8, 10 round (sable or synthetic)

PAINT

Alizarin Crimson • Cadmium Red •
Cadmium Orange • New Gamboge • Permanent Magenta • Phthalo Blue • Phthalo
Green • Ultramarine Blue • Viridian Green

OTHER SUPPLIES

tracing paper • graphite transfer paper •
no. 2 pencil • eraser • craft knife or single-edged razor blade • paper towels • tissue

Blanket flowers (Gaillardia) are bright, colorful flowers that bloom continuously from early summer until frost. There are many fine varieties of Gaillardia, including red, burgundy and even a golden yellow version. They love the sun and attract butterflies and bees.

This version, with its yellow petal and red center, is an excellent lesson in layering bright pigments and charging color wet-into-wet, as well as lifting and picking out highlights. The bee is simply painted, building layers of color, but the effect is exactly what the painting needs.

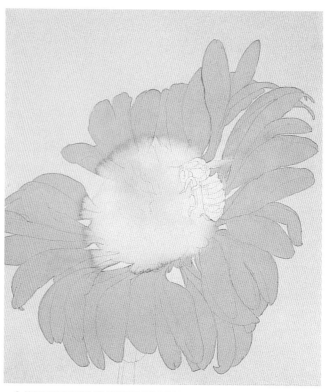

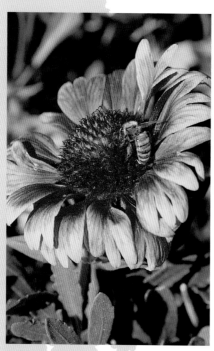

Reference Photo

1 LAY DOWN THE FIRST COLOR

Transfer your drawing to your watercolor paper. Correct your drawing and erase unwanted pencil lines.

Place paper towels under your watercolor paper to prevent backruns. Brush a tint of Cadmium Orange over the entire sheet with a 1-inch (25mm) flat brush. Let dry. Use the same tint of Cadmium Orange to paint each petal; you might need to add more pigment if your initial mixture was weak. As you paint toward the center, lose the edges of the petals by running a damp, clean brush along the edge. While the center is still wet, dab it with Cadmium Orange. Don't be concerned by backruns; the following layers will cover them. (And they can add a touch of naturalism.) Let dry.

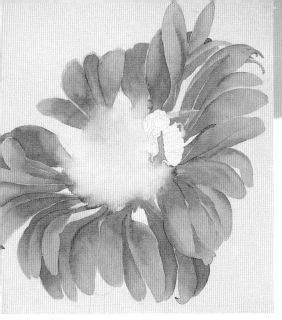

2 ADD MEDIUM VALUES

Lightly erase pencil lines and clean up the edges with a cotton swab. With a medium value Cadmium Red and your no. 8 round, paint the centers of the petals. Paint every other petal to avoid the color running into the wet paint. Let dry.

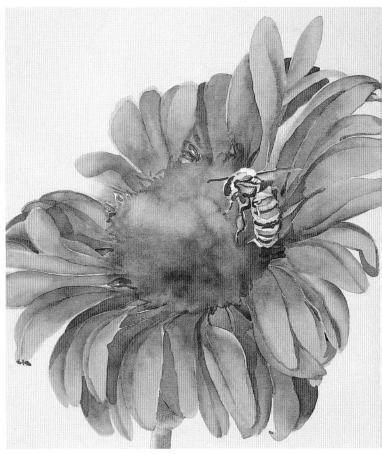

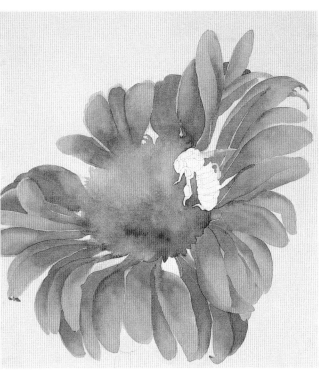

3 PAINT THE FLOWER'S CENTER

Wet the center of the flower, then paint the area with a medium value of Cadmium Red and a no. 8 round. Paint the lighter section Cadmium Orange, wet blending into the red. Let dry.

Painting Small

Sometimes when painting a small area, it works best to use the tip of your brush and paint a series of "dots and dashes" in place of brushstrokes. This method is easy to control and renders a natural appearance.

4 ADD DARKER VALUES

For the shadowed areas on the petals, create a medium value of Alizarin Crimson. Paint using a no. 8 round. Use the same mixture for the center of the flower, wet blending with clear water. Create a leaf green mixture from New Gamboge, Viridian Green and Ultramarine Blue. Paint the stem and the areas that you want to show a touch of green using this mixture and a no. 8 round. Let dry.

Begin painting the bee. Paint the light areas using a mixture of New Gamboge with a little Cadmium Orange, and a no. 6 or 8 round. For the lighter brown sections, create an orange mixture of Cadmium Red and New Gamboge, then add Viridian Green until you have the desired brown color. For the deeper brown, mix Cadmium Red, New Gamboge and Phthalo Green. For the darkest dark, almost a black, mix Alizarin Crimson and Phthalo Green. Let dry.

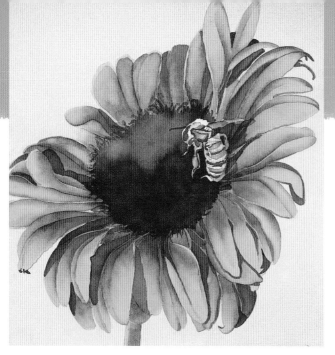

6 STRENGTHEN THE COLORS

Strengthen the red on the petals and in the center with Cadmium Red. Strengthen the shadows with Permanent Magenta. Create three puddles of color: one of Alizarin Crimson, one of Permanent Magenta and one of New Gamboge. Paint these colors in the center of the flower, wet-into-wet. Let dry.

7 COMPLETE THE PAINTING

For the darkest dark in the center of the flower, create a mixture of Alizarin Crimson and Phthalo Green, keeping the color a little on the red side. This color should be more saturated than the previous mixtures. Use a no. 8 round, painting dashes to create the dark accents. Let dry. For the greens, create a mixture of New Gamboge, Phthalo Green and Phthalo Blue. Use this to paint the stem and deeper green areas. Using a small lifting brush and clear water, lift strokes of paint from the flower's center to create highlights, blotting with a tissue as you go. When dry, use a craft knife or single-edged razor blade to scratch out the highlights on the bee and pick lights out of the center of the flower.

HONEY DIPPER
Watercolor on Arches 300-lb. (640gsm) rough-pressed
17" × 15" (43cm × 38cm)

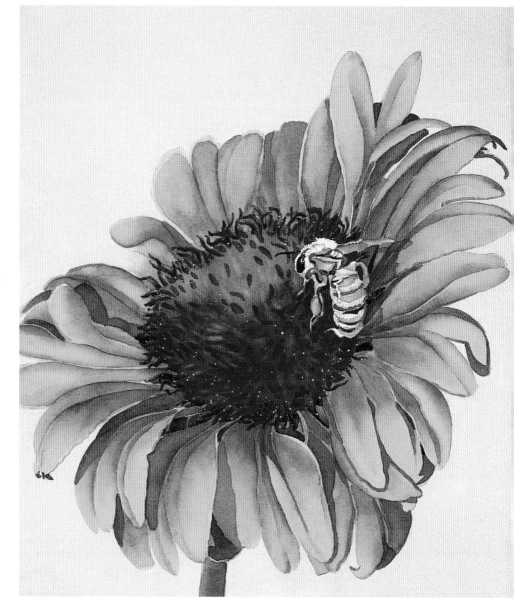

DEMONSTRATION *Magnolia Alexandrina*

MATERIALS LIST

Fabriano 300-lb. (640gsm) rough-pressed
22" × 30" (56cm × 76cm)

BRUSHES
nos. 8 and 10 round (sable or synthetic)

PAINT
Alizarin Crimson • Burnt Sienna • Cerulean Blue • Cobalt Blue • New Gamboge • Permanent Rose • Phthalo Blue • Phthalo Green • Rose Madder Genuine • Ultramarine Blue • Viridian Green

OTHER SUPPLIES
no. 2 pencil • plastic cups • tracing paper • graphite transfer paper • paper towels • tissue

Magnolia Alexandrina is a deciduous tree or shrub, and is often miscalled a "tulip tree" because of the shape and bright colors of its flowers. It blooms in mid-spring before its leaves expand. Its blossoms vary in color from white to pink or purplish red.

This demonstration is a prelude to those in the following pages that include more than one flower subject. In this demonstration, you'll learn to add subject matter and paint a background using layers of yellow, red and blue. If you don't feel comfortable adding more flowers at this stage, choose just one of the flowers to paint. All the flowers are the same species, and will be painted using the same pigments. You may wish to use a larger sheet of watercolor paper for this study, at least a half sheet, or go for it and paint on a full sheet.

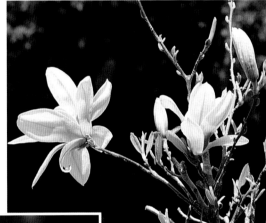

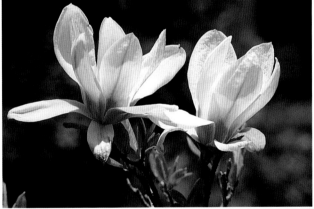

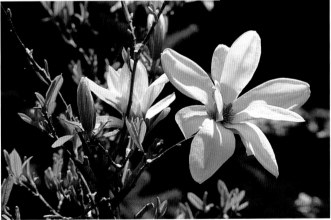

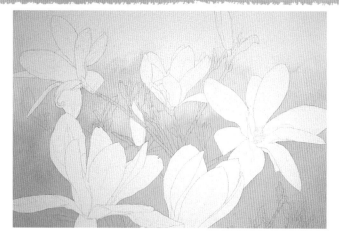

1 LAY THE FIRST BACKGROUND TINT

Draw your preliminary drawing on tracing paper and compose your arrangement using the grid as a guide. When you are satisfied, transfer your drawing to the watercolor paper. Correct it, and erase unwanted pencil lines.

Mix a medium value tint of New Gamboge in a plastic cup. Begin painting at the bottom of your paper with a no. 10 round. Paint around your flower shapes. Work the paint upward, switching to clear water as you near the top. Let dry.

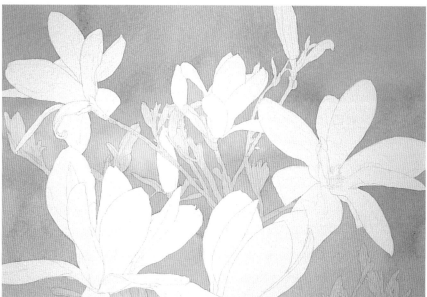

2 LAY THE SECOND BACKGROUND TINT

Mix a medium value tint of Alizarin Crimson in a plastic cup. Beginning at the top and using a no. 10 round, bring the paint down into the yellow, adding clear water toward the bottom of the sheet. Paint around the yellow stem and leaves as well as the flowers. Let dry.

3 GLAZE OVER THE BACKGROUND

Mix a medium value tint of Ultramarine Blue in a plastic cup. Using a no. 10 round and starting at the top, paint down the painting. Work around the stems, leaves and flowers. Use more clear water as you bring the blue to the bottom of the painting. Let this dry.

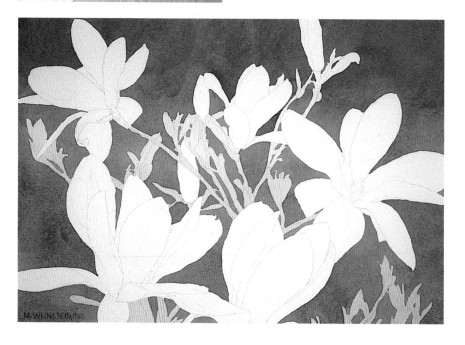

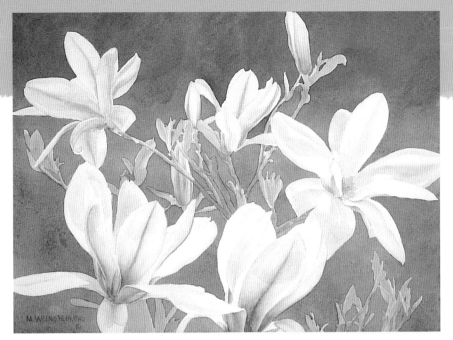

4 PAINT THE BLOSSOMS

Mix a medium value tint of Rose Madder Genuine and paint the pinks on the flowers with a no. 8 round. When dry, mix Cerulean Blue and Rose Madder Genuine to a "barely there" violet, and paint the shadows on the petals. For the green leaves, mix a tint of New Gamboge and Viridian Green, adding a touch of Cobalt Blue. Paint the leaves with a no. 8 round. Use Burnt Sienna to paint the twiggy branches, keeping the color in the shadow side. Run a brush loaded with clear water down the light side of the branch to soften the edge. Apply New Gamboge to the center of the flower on the far right. Let dry.

Rest Areas

Notice that in my arrangement of the shapes that I have allowed for "rest areas" around the painting so that I don't have to paint the entire background in one go. Always try to plan your painting to allow for this. It will make painting in large backgrounds much easier.

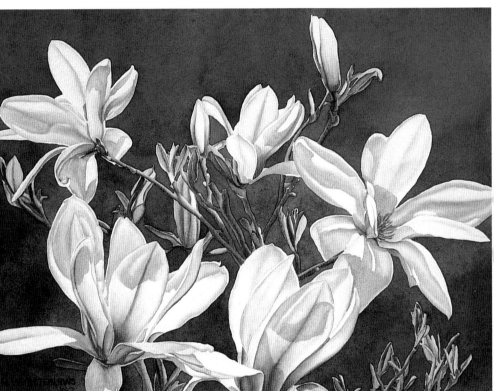

5 STRENGTHEN THE COLOR

Strengthen the pink to red on the petals with Permanent Rose. When this dries, deepen the shadows using the original, barely there violet mixture of Rose Madder Genuine and Cerulean Blue. Glaze the right-hand flower's center with Rose Madder Genuine to deepen the yellow to an orange. For the darks on the leaves, create a mixture of New Gamboge, Phthalo Green and Phthalo Blue, and paint using a no. 8 round. Use Burnt Sienna to deepen the color on the branches. Let dry. To finish the background, mix a rich blue of Ultramarine Blue and Phthalo Blue in a plastic cup (make sure you have plenty). On a piece of scrap watercolor paper, test the mixture before painting. Using a no. 10 round, begin at the top and paint around the shapes, bringing the blue all the way down to the bottom of the watercolor paper. Let dry.

ENCHANTMENT | *Watercolor on Fabriano handmade 300-lb. (640gsm) rough-pressed* | *22" × 30" (56cm × 76cm)*

MATERIALS LIST

Arches 550-lb. (1155gsm) rough-pressed
41"× 29" (104cm × 74cm)

BRUSHES
nos. 6, 8, 10 round (sable or synthetic)

WATERCOLOR
Aureolin Yellow • Cadmium Orange •
Cadmium Yellow • Cerulean Blue • Cobalt
Blue • New Gamboge • Permanent Rose •
Quinacridone Red • Rose Madder Genuine
• Sap Green • Viridian Green

ACRYLIC
Cadmium Orange • Cadmium Red
• Cadmium Yellow • Cerulean Blue •
Cobalt Blue • Jenkins Green • Naphthol
Crimson • Permanent Rose • Phthalo Blue
• Phthalo Green • Quinacridone Red •
Titanium White • Ultramarine Blue

OTHER SUPPLIES
acrylic matte medium spray • acrylic matte
• medium liquid • acrylic matte medium
soft gel (Golden) • acrylic retarder medium
(Golden) • tracing paper • eraser • craft
knife or single-edged razor blade • no. 2
pencil • graphite transfer paper • paper
towels • alcohol • cotton swabs

The preceding demonstrations and exercises introduced you to basic procedures
and techniques. The following demonstrations are larger, finished paintings that
are more complex (or appear to be).

The composition of this garden flower painting is arranged as you might arrange
flowers in a vase: Smaller blossoms in the foreground, mid-sized behind them and
the taller ones taking up the rear. Select the flowers that you would like to paint and
arrange them in a composition of your choosing, and then follow the instructions
that pertain to your selected blossoms.

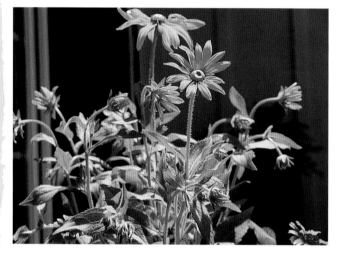

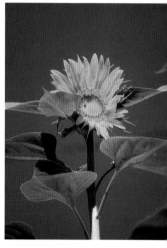

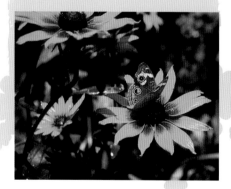

.WEINSTEIN,NWS

1 LAY DOWN THE LIGHT TINTS OF LOCAL COLORS

Transfer your drawing to the watercolor paper, then erase unwanted pencil lines.

Establish the tone of each plant. Your goal at this stage is to cover the entire sheet with a tint of color, leaving only white paper where the object is to remain white. Start with yellow. Mix a good-sized batch of New Gamboge in a plastic cup (save any leftover paint to use later). With a no. 10 round, lay a wash of yellow over any area that will be yellow, green or orange.

Red is the next color. Paint Rose Madder Genuine over any flower that will be red or pink. Tint the background with Cobalt Blue. Mix up a good quantity in a plastic cup—you don't want to run short. Save the leftover color in a mason jar.

2 DEEPEN THE COLOR AND PAINT THE LEAVES

Using a no. 8 round and Cadmium Yellow, deepen the values of all the yellow flowers. To deepen the color of the leaves and model the form, mix a puddle of New Gamboge and Viridian Green plus Cerulean Blue, and paint the leaves of the sunflowers. For the hollyhock leaves, use the same mixture with a little more Viridian Green. Save areas of yellow on the leaves, wet blending your color to soften the effect. Deepen the color of the red blossoms with an application Quinacridone Red. For the pink blossoms, deepen the color with Permanent Rose.

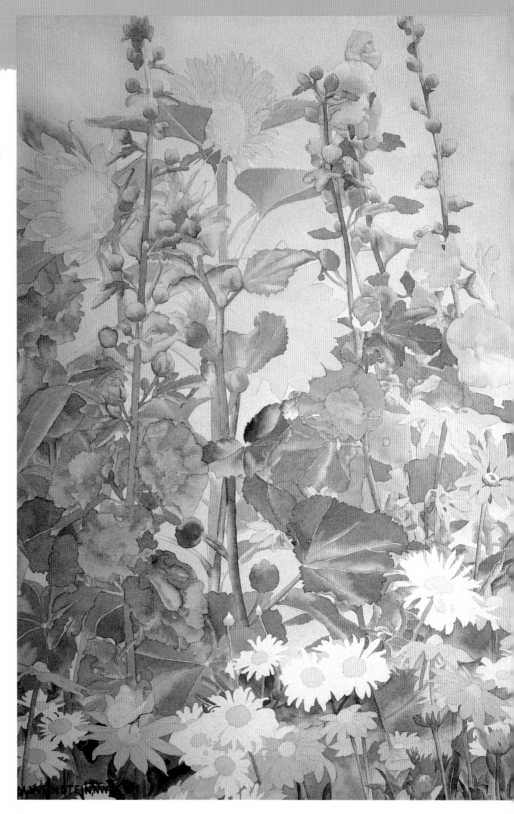

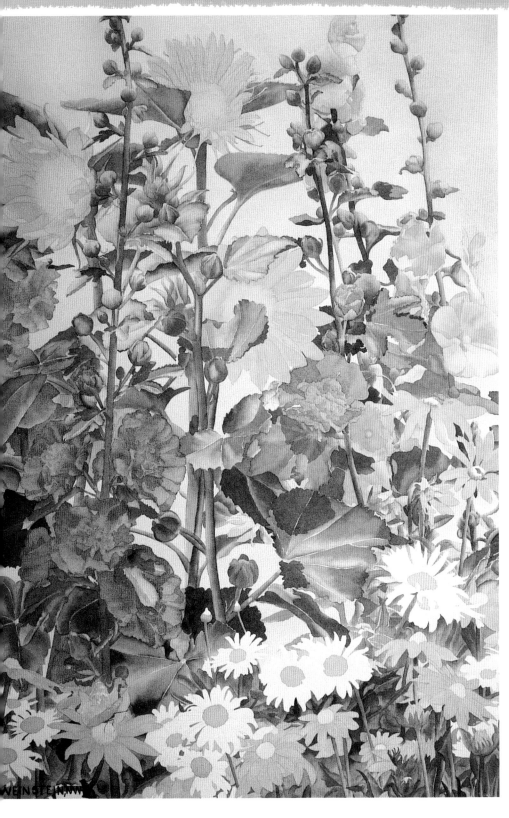

ADD LAYERS OF COLOR

3 Model the form of the sunflower petals with Cadmium Orange. When this is dry, glaze Aureolin Yellow over the entire flower using a no. 8 round. Paint the center of the pink hollyhocks with Cadmium Yellow, then model their forms with Quinacridone Red. Model the daisies using a no. 8 round and Cadmium Orange. Create a dark mixture with Cadmium Yellow, Phthalo Green and Ultramarine Blue, then glaze the leaves with this mixture.

4 ADD SHADOWS AND SEAL THE PAPER

The shadow color for the yellow flowers should be a mixture of Sap Green and Permanent Rose, just a tint of color. For the white flowers, create the shadows using a mixture of Cerulean Blue and Cadmium Orange. Use Cobalt Blue for the shadows in the red blossoms and Cerulean Blue for the shadows in the pink blossoms. Let dry.

At this point, seal in the watercolor paint by spraying the painting with acrylic matte medium. If you want to continue the painting in watercolor, skip this step.

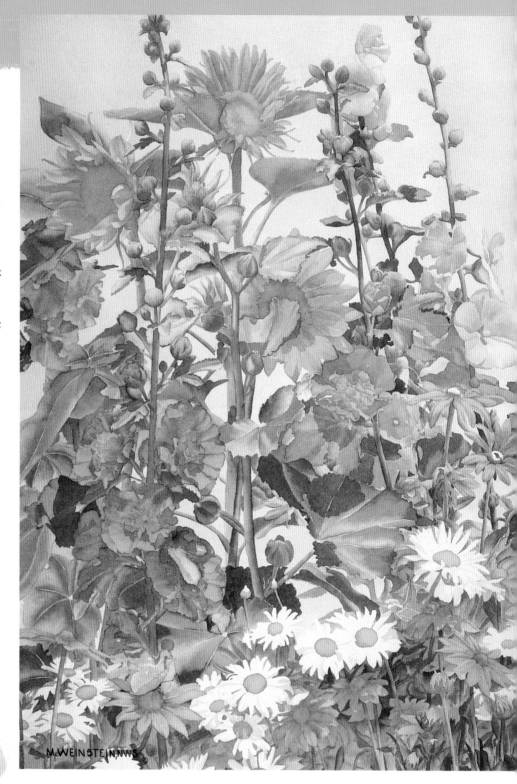

M.WEINSTEIN,NWS

Buckling Paper

If your paper shows signs of buckling during the painting process, turn it over and spray the back with water. Flip it back over, weigh the paper down and let it dry.

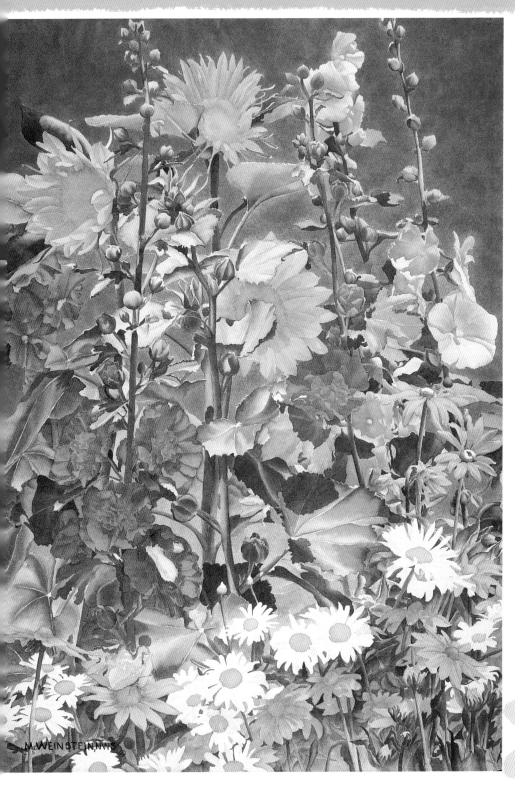

M. WEINSTEIN, NWS

5 INTENSIFY THE COLOR WITH ACRYLIC

Thin the acrylic paint with water and matte medium until it has a consistency similar to watercolor, then add a drop or two of acrylic retarding medium. Use a no. 8 synthetic round to paint during this step, cleaning it thoroughly when you're finished painting. Paint the red flowers with Naphthol Crimson for their first layer. Follow with an application of Quinacridone Red. Glaze the pink hollyhocks with Permanent Rose. Intensify the yellow centers of the sunflowers with Cadmium Yellow. Deepen the color of the leaves with a mixture of Cadmium Yellow, Phthalo Green and Phthalo Blue. For the blue background mix a large amount of Cobalt Blue, Cerulean Blue and Ultramarine Blue. Using a no. 10 synthetic round, paint the background.

Acrylic and Brushes

When you're finished painting using a brush for an acrylic section, rinse the brush. Keep the brush in water during the rest of the painting sessions to prevent acrylic from drying on the brushes and then clean them thoroughly.

6 FINALIZE THE COLORS

Use the same palette of acrylic paint to finish the painting, with the addition of acrylic soft matte medium in place of the liquid medium. Vary the thickness of the pigment to manipulate the body and transparency. Glaze the yellows with a transparent Cadmium Yellow to increase intensity. Paint the petals of the sunflowers and the daisies with glazes of Cadmium Orange and Cadmium Red for added warmth. Paint the sunflower centers with a warm brown mixed from Cadmium Yellow, Cadmium Red and Phthalo Green. Mix the Cadmium Yellow and Cadmium Red to a rich orange first, then add a little bit of Phthalo Green until you have the color that you want. Also use this mixture for the daisy centers. Continue around the painting, applying glazes of color where needed.

To finish the leaves, add Jenkins Green to the darkest areas. Apply another layer of the warm brown to the sunflower centers.

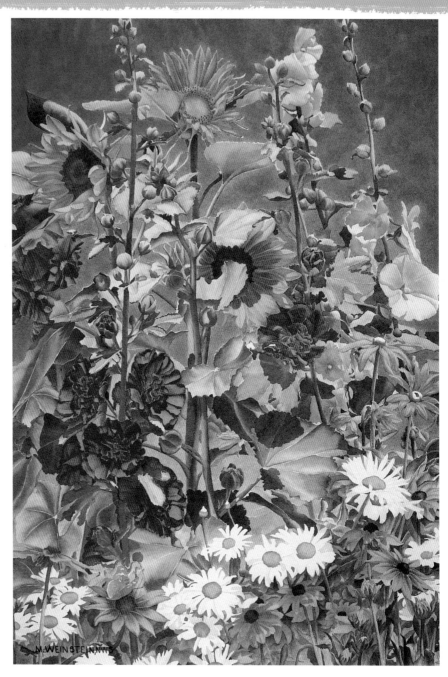

Little Butterfly

There's a little butterfly in the lower left corner of the painting—not an important element, just a touch of whimsy. This one is handled simply, built up with glazes of color. In the beginning, I laid down a wash of New Gamboge, followed by Cadmium Yellow, then Cadmium Orange. The final color on the wings is a light brown color mixed from Cadmium Yellow, Cadmium Red and Phthalo Green. The white areas on the wings and wing tips were scraped out with a single-edged razor blade.

104

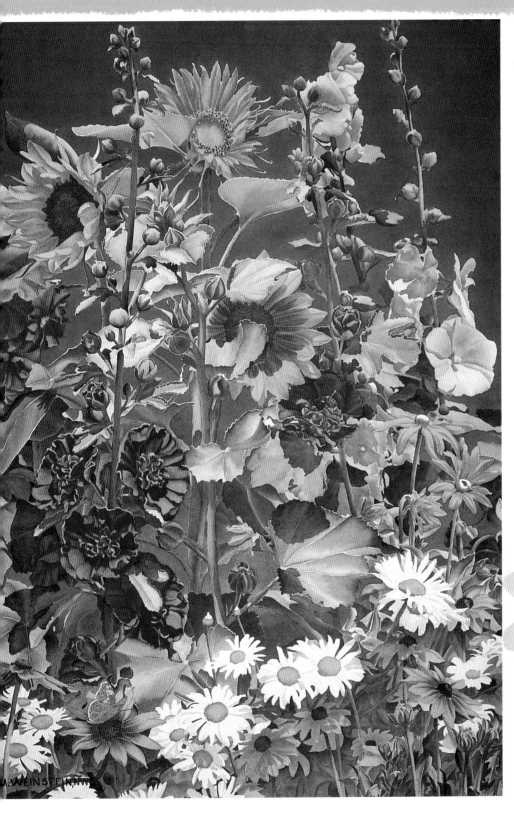

7 DEEPEN THE BACKGROUND

To reinforce the background with acrylics, you'll need three mixtures. The first is a good-sized batch of a rich blue made from Ultramarine Blue, Phthalo Blue and Cerulean Blue. The second is a puddle of Phthalo Blue, and the last is a puddle of Phthalo Green.

Starting at the upper left corner, paint the upper area with the rich blue mixture using a no. 10 synthetic round. You have many "rest" areas to stop as you paint. When you've gone past the halfway point, begin blending in Phthalo Blue and Phthalo Green in different areas. Glaze the blue over some of the leaves in the background to make them recede and add a feeling of space. Add a little Titanium White to Cadmium Red, then use your smallest brush to add highlights on the red hollyhocks. When this is dry, spray the painting with three to five coats of acrylic matte medium.

Lifting Color

If you need to "lift" areas of dried acrylic pigment, moisten a cotton swab or lifting brush with alcohol. Gently rub the area and blot with a clean cloth. Let dry and then apply glazes of color to blend the area into the rest of the painting.

COUNTRY CHARMERS | *Watercolor/acrylic on Arches 550-lb. (1155gsm) rough-pressed* | *41" × 29" (104cm × 74cm)* | *Collection of Mr. and Mrs. George Fermanian*

MATERIALS LIST

Arches 550-lb. (1155gsm) rough-pressed
41" × 29" (104cm × 74cm)

BRUSHES
nos. 6, 8, 10 round (sable or synthetic)

PAINT
Burnt Sienna • Cadmium Orange •
Cerulean Blue • Cobalt Blue • Neutral
Tint • New Gamboge • Permanent Rose •
Phthalo Blue • Phthalo Green • Quina-
cridone Pink • Rose Madder Genuine •
Scarlet Lake • Ultramarine Blue • Viridian
Green • Winsor Red (Winsor & Newton)

OTHER SUPPLIES
tracing paper • graphite transfer paper •
no. 2 pencil • small sponge • craft knife or
single-edged razor blade • no. 0 scrubber •
eraser • paper towels • tissue

It's hard to resist painting roses—so many beautiful colors and forms to choose from! I have painted these same roses in various arrangements and colors, some-times red, other times a soft pink. (As the artist, you can change the color at will). In this painting, I chose to paint with a warmer pink, red and orange palette. The little butterfly was added as a surprise touch. The sky is from my imagination; use your imagination to create your own personal sky.

M.BACKER, NWS
©

1 PAINT THE FIRST TINTS AND THE SKY

Transfer your drawing to the watercolor paper and erase unwanted pencil lines.

The first tints of color should be New Gamboge and Quinacridone Pink. To achieve the desired tint, mix a pea-sized amount of color with water in plastic cups. Beginning at the bottom, paint upward with a no. 10 round loaded with New Gamboge, going around the flower shapes. When the bottom third of the painting's background—up to the horizon—is painted, switch to Quinacridone Pink. Paint the middle third of the painting and then continue to the top with clear water. Let this dry, then paint New Gamboge in the centers of the roses and the butterfly. Use the pink tint to paint the rose stems. Let dry.

The sky is an important element in this painting. Paint it first, before you spend a lot of time painting the roses in case it doesn't come out to your satisfaction. Whether you paint the sky from your imagination or from a reference photo, the process is the same. Dampen the upper sky with clear water. While you're waiting for the shine to leave the paper, mix up a good-sized batch of a blue sky color (Cerulean Blue, Cobalt Blue and Ultramarine Blue). Using a no. 10 round and beginning at the top, paint this blue mixture across the paper using big, loose brushstrokes. Keep the brush loaded with pigment. Working as quickly as you can, bring the sky all the way down to the bottom of the paper, glazing over previous color. While the paint is still damp, take a small, damp sponge and sweep across the sky, imitating wispy cloud formations. In some areas, blot with a small sponge, or a tissue. You don't have to be precise; just visualize cloud formations as you work. When the result pleases you, stop and let the paper dry.

2 PAINT THE PETALS

Load your no. 8 round with Permanent Rose, making sure the paint is just a little more saturated than a tint. Apply the first layer of color to the rose petals. Work from the center outward and blend toward the edges with clear water for a soft look. Let this dry.

For the leaves, create a green mixture of New Gamboge, Viridian Green and Cobalt Blue. Using a no. 8 round, use this green to model the form of the leaves. Paint the stems as well. Paint the dark areas of the butterfly with Neutral Tint and a no. 6 round. Let dry.

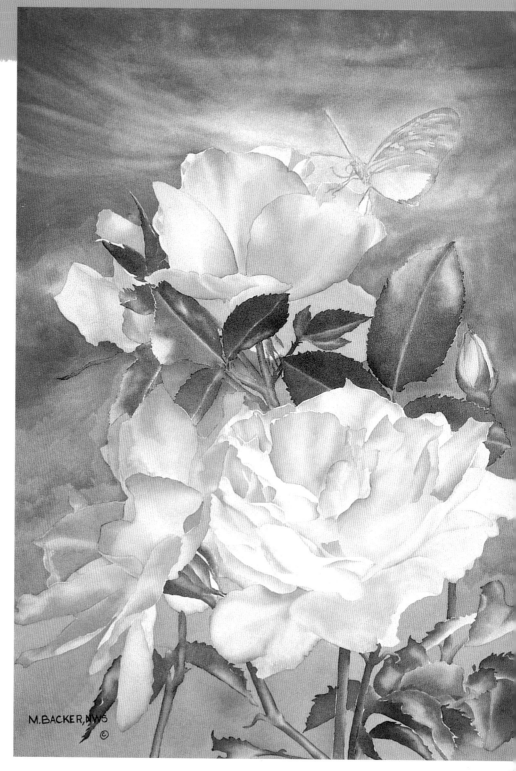

M. BACKER, NWS
©

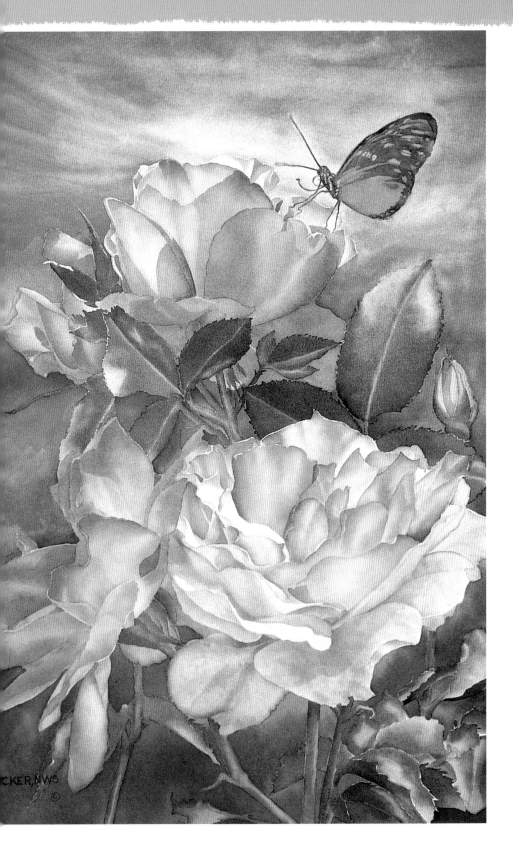

3 PAINT THE SHADOWS AND DEEPEN THE COLORS

Mix a tint of Cobalt Blue and paint the shadows on the petals and leaves. Bring some of the blue into the dark areas on the butterfly wings. For the orange areas, glaze with Cadmium Orange and Scarlet Lake. Add a layer of New Gamboge to the yellow parts and Neutral Tint to the dark areas.

Deepen the color of the rose petals with Rose Madder Genuine, modeling form as you go.

Add the impression of plant material to the lower background. Create a watery green mixture of New Gamboge, Viridian Green and Cobalt Blue—not too little pigment, nor too much. Using a no. 10 round, paint this mixture over the lower background. Randomly add Cobalt Blue to various areas. As you near the sky, thin the color with clear water, blending as you go. Let this dry.

4 INTENSIFY THE COLOR

Add leaves to the left side to fill it in. Use a mixture of New Gamboge, Viridian Green and Cobalt Blue. This should be fairly easy to do because the background is light and has the blue in it.

To deepen the color in the leaves, mix New Gamboge, Phthalo Green and Phthalo Blue, and using a no. 8 round, paint the darks in the leaves.

Echo some of the butterfly's colors in the roses. Look for areas in the petals to place Cadmium Orange and Scarlet Lake. Glaze Permanent Rose over the petals, modeling the form and deepening the value.

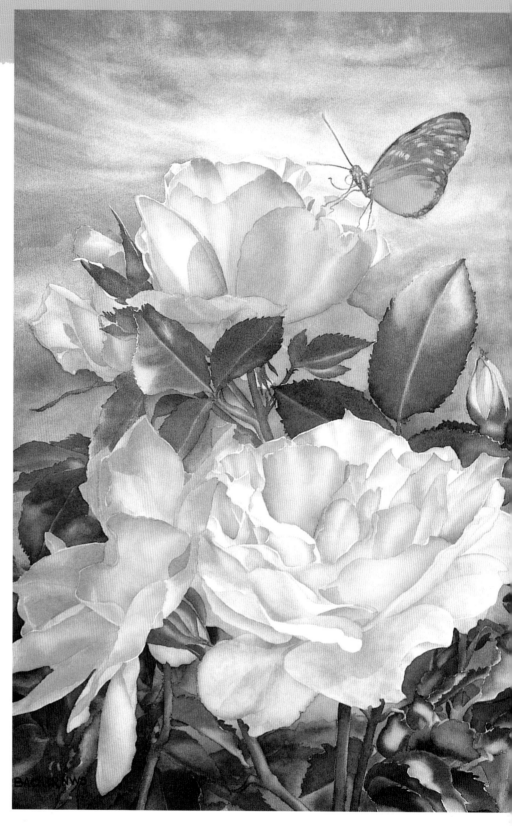

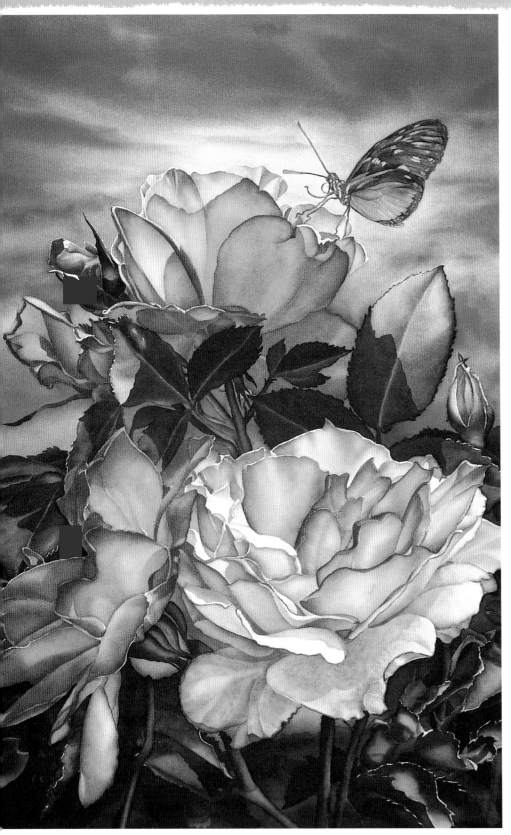

5 PAINT THE SKY

Using a no. 10 round loaded with the original blue sky mixture (Cobalt Blue, Cerulean Blue and Ultramarine Blue), and working on dry paper, paint the background, bringing the blue into the greens of the lower area. Paint over some of the leaves in the background to push them back and add a feeling of depth.

Add Scarlet Lake to the rose on the lower left, and then glaze with a layer of Winsor Red. Use Winsor Red to deepen the color of the other roses and to edge the petals.

With a no. 8 round and a mixture of New Gamboge, Phthalo Green and Phthalo Blue, paint the final darks in the leaves. Let dry. Take this same paint mixture and add it to the background as needed.

Add glazes of Burnt Sienna and Rose Madder Genuine to the butterfly. With your lifting brush, lift out any lights that you may have lost throughout the painting. With a single-edged razor blade, lift out some highlights.

Take a good look at your work. Do any areas need more color? Better values? Or is the painting finished? Analyze your painting to see if it needs any additional details. Prop the painting up where you can see it as you enter the room. Leave it there for a day or two. It sometimes helps to turn the painting upside down for a different viewpoint. Make adjustments as necessary.

AMBROSIA | *Watercolor on Arches 550-lb. (1155gsm) rough-pressed* | *41" × 29" (104cm × 74cm)*

MATERIALS LIST

Arches 300-lb. (640gsm) rough-pressed
22" × 30" (56cm × 76cm)

BRUSHES
nos. 6, 8, 10 round (sable or synthetic)
no. 0 scrubber

PAINT
Alizarin Crimson • Burnt Sienna • Cadmium Red • Cadmium Yellow • Cerulean Blue • Cobalt Blue • New Gamboge • Permanent Green • Permanent Rose • Phthalo Blue • Phthalo Green • Ultramarine Blue • Viridian Green

OTHER SUPPLIES
no. 2 pencil • eraser • tracing paper • graphite transfer paper • paper towels • tissue • 1-inch (25mm) masking tape • cotton swabs • small sponge • craft knife or single-edged razor blade • toothbrush

Walking along a rural road, I came across this little geranium growing out between the boards of a neglected fence, reaching for the sun and struggling to survive. I snapped a photograph, thinking that it might be material for a future painting. As I was researching my files for demonstration ideas, I came across the image and decided to paint it. As you can see, I changed the composition, adding a little landscape and using a horizontal format.

In this demonstration you will learn how to paint the look of old, weathered wood, a simple flower and a landscape.

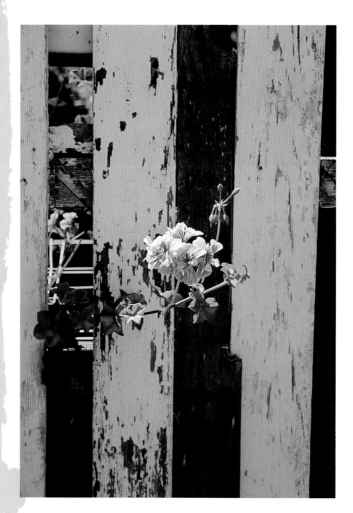

M.BACKER,NWS

PAINT THE LANDSCAPE

1 Transfer your drawing to your watercolor paper. Correct the image and erase unwanted pencil lines.

Lightly sketch in the cloud shapes. Then, using the largest brush, wet the cloud shapes with clear water. You will be working wet-into-wet for the sky area. Create a mixture of Cobalt Blue, Cerulean Blue and Ultramarine Blue in a small mason jar. Using this mixture and the largest brush, paint the sky around the damp cloud shapes, letting the color blend into the edges. With a damp sponge and/or tissue, lift out the cloud shapes. Let this dry, then apply a light tint of New Gamboge over the field. When the yellow is dry, paint the shape of the distant mountains using Cobalt Blue, blending downward with clear water. While the paint is still wet, tint the area below the mountains with a mixture of Permanent Rose and New Gamboge. Paint the area using horizontal brushstrokes. Let dry.

MBACKER,NWS

2 PAINT THE FIELD

Create a mixture of New Gamboge, Permanent Green and Cobalt Blue. Using horizontal brushstrokes, paint the field. Create a mixture of New Gamboge, Viridian Green and Ultramarine Blue. Paint the lower area of the land with this mixture, using vertical strokes to give the impression of grasses. While the paint is still wet, remove the excess water from the brush and then stroke the brush upward through the green paint to give the impression of grass. Let dry. To create the impression of other organic matter, try spattering brown paint. First create a warm brown using Burnt Sienna and Ultramarine Blue, adding just enough water to dampen it. Place paper towels around the area you wish to spatter in order to protect the rest of the painting. Dip a damp toothbrush into the warm brown mixture and spatter over the field. Let dry.

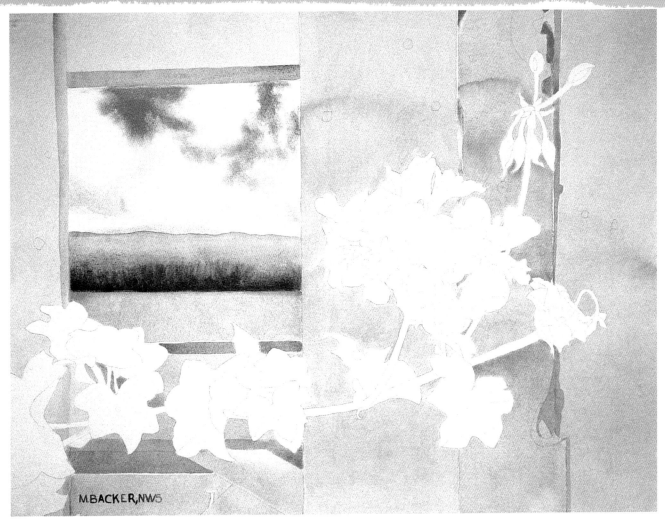

M.BACKER, NW5

3 PAINT THE BOARDS

We're viewing the fence posts on the shadowed side, which you should establish before moving on. Create a watery mixture of New Gamboge, Permanent Rose and Cerulean Blue. This will produce a warm gray tint. Using a no. 10 round, paint the white boards with this mixture. Let dry. Create another gray tint from Burnt Sienna and Ultramarine Blue and apply it to the brown board. When the paint is dry, take your Burnt Sienna and Ultramarine Blue mix and paint the edges of shadowed boards with the second gray tint. Paint the areas where the sky peeks through with the Cobalt Blue, Cerulean Blue and Ultramarine Blue mixture from step 1. Let this dry, then clean the edges with a damp cotton swab.

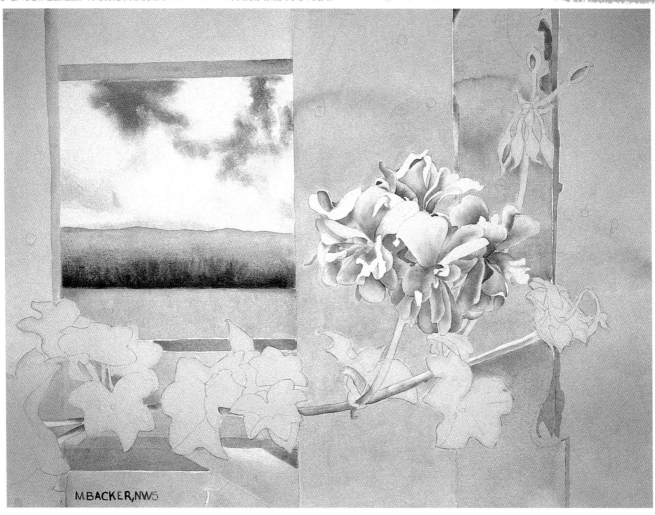

M.BACKER, NWS

4 PAINT THE LEAVES AND PETALS

Paint the leaves a medium value New Gamboge using a no. 8 round. Paint the flowers a medium value Permanent Rose. Begin in the center of each petal, losing the edge with clear water as you work to the outer edges of the blossom. Apply this same tint to the shadow part of the stems. Let everything dry.

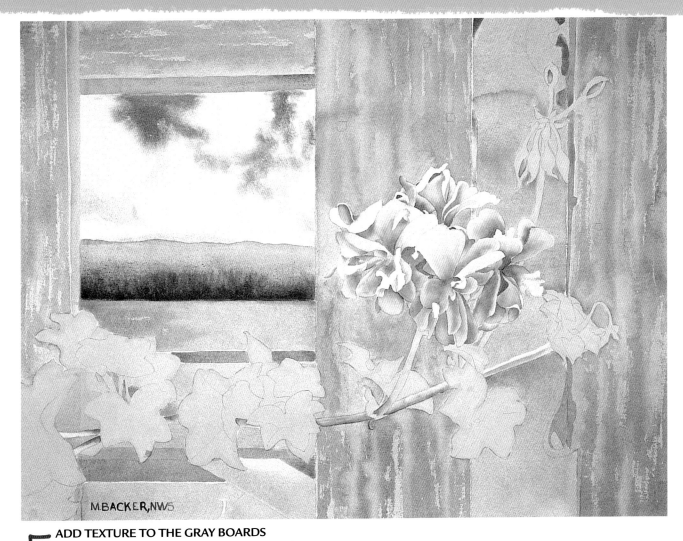

M.BACKER, NWS

5 ADD TEXTURE TO THE GRAY BOARDS

Mask the edges of the horizontal board at the top for a nice clean edge. Create a watery mixture of New Gamboge, Cadmium Red and Cerulean Blue. Load a no. 8 round with this warm gray color. Drag the brush on its side in the direction of the wood grain. Lose some of the edges with a brushstroke of clear water. Do this here and there as you work down and across the board. When this board is complete, repeat the process with all the other gray boards (but not the brown one), masking the edges of each one as you work. Vary the mix from time to time, adding a little more red, blue or yellow. The boards don't have to be perfectly matched.

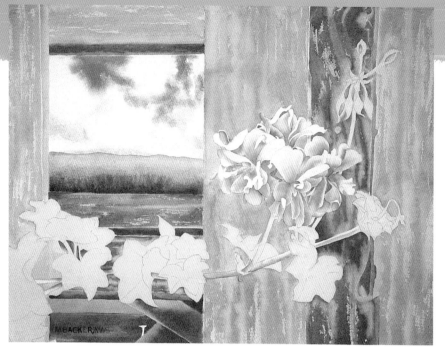

6 PAINT THE BROWN BOARD AND AREAS

Create a warm brown mixture from Cadmium Yellow, Cadmium Red and Viridian Green. You can substitute this with a mixture of Burnt Sienna and Ultramarine Blue for the brown, but I prefer the first mix; the green shows through, bringing some life to the aged quality. Load a no. 8 round with the mixture you've chosen to work with. Using a loose grip, lightly drag the brush on its side in the direction of the wood grain. Randomly wet the edges of the paint with clear water. Let dry.

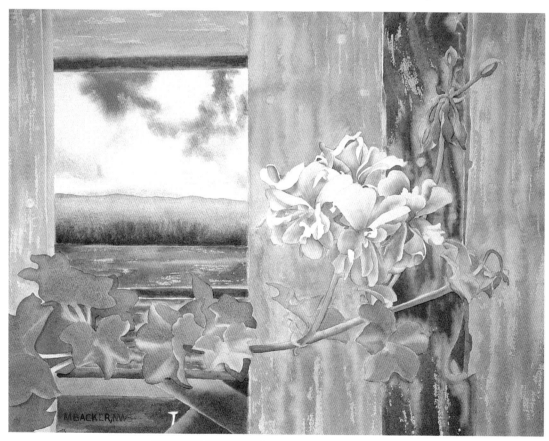

7 ADD THE SHADOWS

Create a yellow-green mixture from New Gamboge, Viridian Green and Cobalt Blue and begin painting the darks of the leaves. When you reach the leaves that are in shadow, add more Cobalt Blue to the mixture.

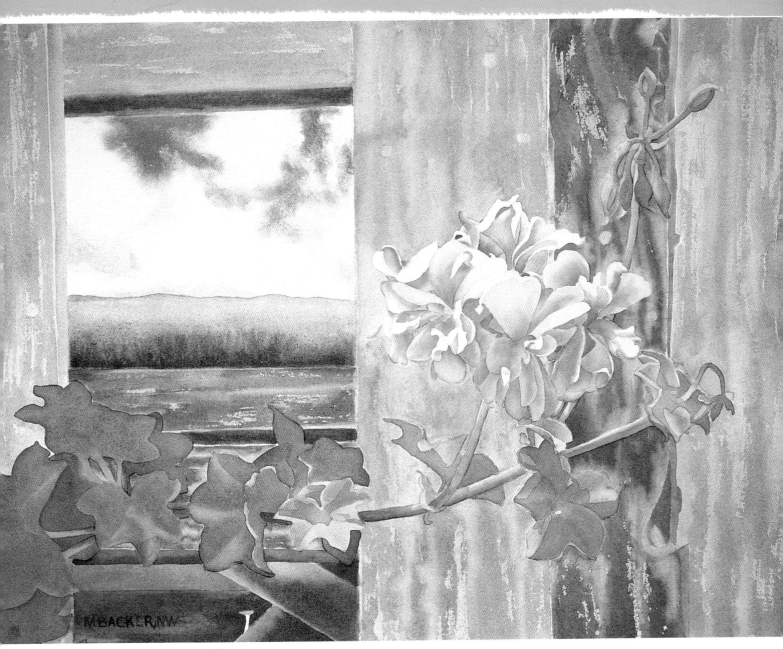

8 DEEPEN THE VALUES

Paint the shadow areas with a tint of Phthalo Blue. Bring the mix down into the boards that are beneath the leafy area. For the shadow areas on the flower petals, use Cobalt Blue.

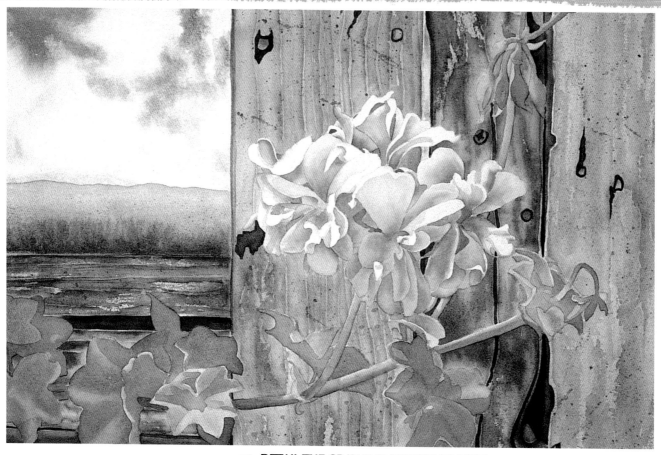

9 DETAIL THE GRAY AND BROWN BOARDS

Begin with the gray boards. Create a mixture of Cadmium Yellow, Cadmium Red and Cerulean Blue, but don't add too much water. You want a warm gray color, a little deeper than the underpainting. Load a no. 8 round with this mixture, then drag the brush vertically up and down in the direction of the grain. When this is dry, load a toothbrush with some of the leftover mixture, and spatter the wood. Protect the areas of your painting that you don't want spattered with paper towels. If this does happen, take a tissue and quickly blot it up.

For the brown boards, create a rich brown mixture of Cadmium Yellow, Cadmium Red and Phthalo Green and apply in the same manner. When this dries, spatter the boards with the leftover mixture, again protecting the other areas with paper towels. Paint the rusty nails Burnt Sienna. To paint the darks, use the barely diluted brown mixture.

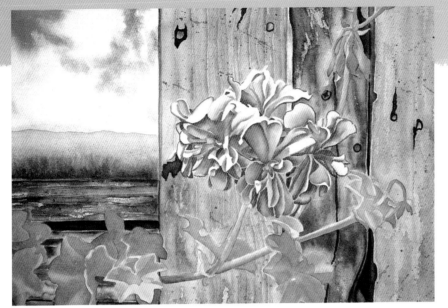

10 PAINT THE PETALS' DARKS
Paint the darks of the flower petals Permanent Rose. When this dries, clean up the edges of the flower and leaves with a damp brush or cotton swab.

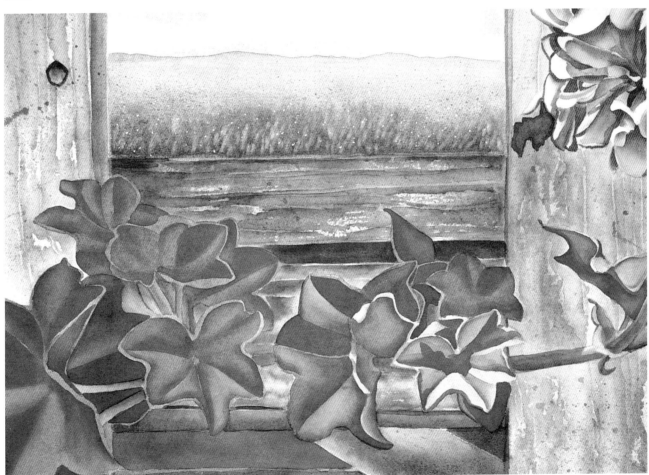

11 BUILD THE DARKS OF THE LEAVES
To build the darks of the leaves, create a mixture of Cadmium Yellow, Phthalo Green and Phthalo Blue. Apply this color to the leaves that are in the light with a no. 8 round. For the leaves that are in shadow, add more Phthalo Blue. Bring the green mixture down into the open space between the boards. (You're setting this area up for negative painting later on.)

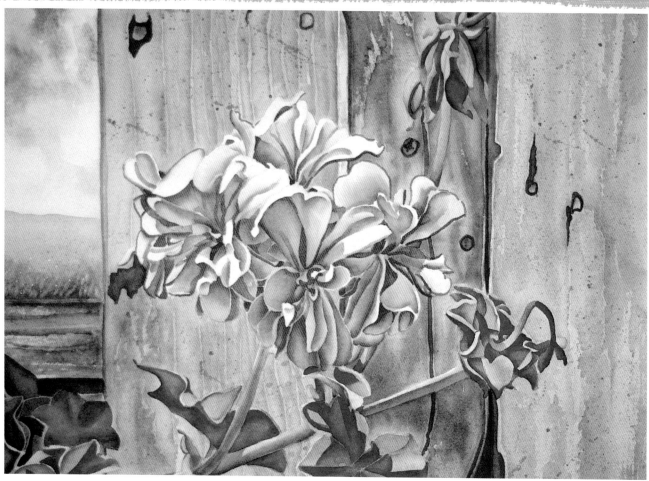

12 THE DARK ACCENTS ON THE PETALS

For the darkest dark accent on the flower petals, apply Alizarin Crimson using a no. 6 round for the details. Paint the darks on the leaves with a mixture of Cadmium Yellow, Phthalo Green and Phthalo Blue. Keep the form simple.

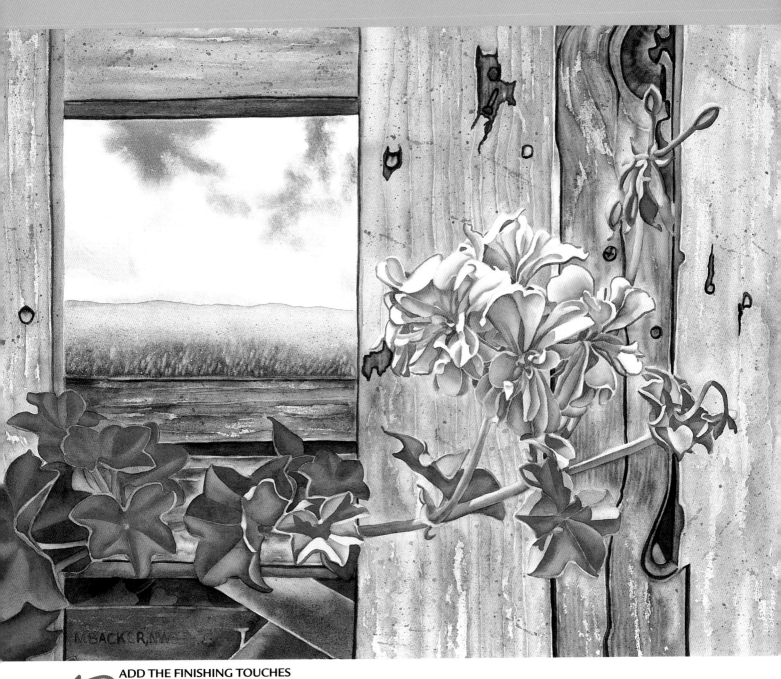

ADD THE FINISHING TOUCHES

13 To paint the final darks on the wood, create an almost black mixture of Alizarin Crimson and Phthalo Green. Use this mixture for the cracks between the boards and all the dark accents.

Paint the shadow area between the boards using a negative painting technique. First, lightly draw the shapes of a few leaves. Using a tint of Phthalo Blue, paint around the leaf shapes. Continue to build this area with additional layers. For the darkest dark, apply the Alizarin Crimson and Phthalo Green mixture.

Dampen a little bristle brush and use it to lift wood grain out from the brown wood. Use this same technique to lift lights out from the foreground of the field area. Use a craft knife or a single-edged razor blade to pick out lights in the field to give a hint of wildflowers.

Evaluate your painting and make adjustments where necessary.

DON'T FENCE ME IN | *Watercolor on Arches 300-lb. (640gsm) rough-pressed* | *22" × 30" (56cm × 76cm)*

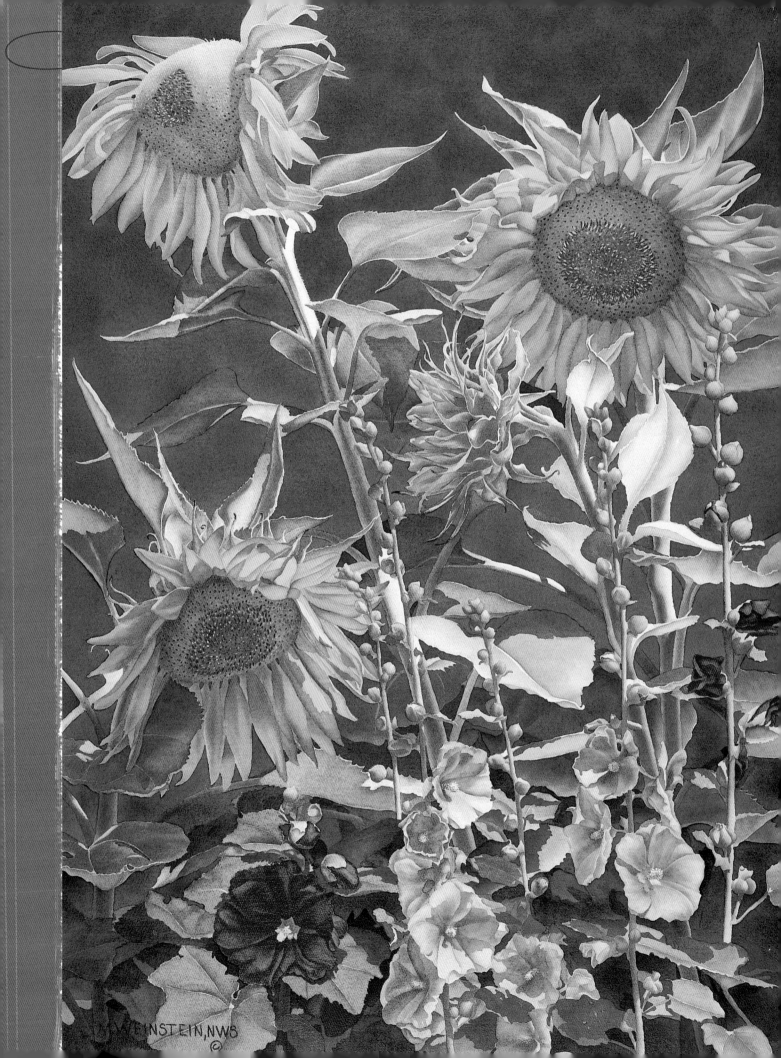

M. WEINSTEIN, NWS

Conclusion

As an artist, I enjoy sharing my goals and methods. Throughout this book, my goal has been to share information with you regarding watercolor processes, techniques, helpful tips and related practical matters on how to create beautiful flowers. Much of what I know about painting I learned from books like this one. In the early years of my development, I took workshops and classes with artists whom I admired. Scott Moore showed me the importance of values in painting. Robert E. Wood opened up the world of color to me and when he awarded my painting, *Georgia on My Mind*, the National Watercolor Society Award in the 1997 Watercolor West Annual Exhibit, it was one of the most gratifying awards that I have received. It made me realize that dreams do come true. Linda Stevens Moyer's skill in working with layers of color, stacked one on top of the other, fascinated me. This technique has become my preferred working method.

Watercolor painting can't really be boiled down to a formula. The learning process is a continuous one, each painting a new learning experience. My advice is to rely on your instincts and emotions. Believe in yourself and paint to your own satisfaction. Be a sponge and soak up as much information and advice as you can from other artists, students and teachers. Take one step at a time, and don't feel you have to rush to get to a certain level. Set goals for yourself and work to achieve them. You learn by doing, so the best advice that I give to you is to paint. See it in your mind's eye. Feel it and then paint it. And as you stroll through the garden of life, take the time to stop and smell the roses.

My hope is that you have enjoyed learning from this book as much as I have enjoyed creating it.

Happy Painting!

SUNCATCHERS | *Watercolor/acrylic on Arches 550-lb. (1155gsm) rough-pressed* | *41" × 29" (104cm × 74cm)* | *Collection of J. Koch*

Index

Metric Conversion Chart

To convert	to	multiply by
Inches	Centimeters	2.54
Centimeters	Inches	0.4
Feet	Centimeters	30.5
Centimeters	Feet	0.03
Yards	Meters	0.9
Meters	Yards	1.1

Learn to paint stunning watercolors with these other fine North Light Books!

Donald Vorhees has been painting and teaching in watercolors for most of his life, and has accumulated a wealth of knowledge that he lovingly imparts in this comprehensive book. More than 25 demos accompany his written explanations, making it easy for beginning artists to visualize and practice the techniques. Scattered throughout the book are anecdotes and insights, tips and tricks, all designed to help you get an artist's sense of watercolor painting. The book is designed to be easy to use, with tabs for quick access to specific techniques and subjects. Beginners and advanced artists alike will find inspiration and guidance within these pages.

ISBN-13: 978-1-58180-775-2; ISBN-10: 1-58180-775-9; HARDCOVER WITH ENCLOSED SPIRAL, 144 PAGES, #33446

In *Master Disaster*, artist and instructor Sue Tregay shows you how to change mediocre paintings into spectacular works of art. Learn to evaluate your compositions and rework them using five simple, unique steps: lighten it up, break it up, enrich it, unify it and surprise us. The book also contains valuable advice on producing competition-quality art, what judges want and how to frame your work—things all artists need to know to turn their hobby into a successful money-making venture.

ISBN-13: 978-1-58180-795-0; ISBN-10: 1-58180-795-3; PAPERBACK, 128 PAGES, #33471

In *Stunning Crystal and Glass*, dramatic light-filled paintings become possible no matter what your skill level. Where most watercolorists paint from light to dark, expert Joyce Faulknor teaches how to go from dark to light—a technique she says is easier to learn and ultimately adds more depth and texture to any work. Composition examples show ways to add flowers, colorful cloth and reflective surfaces to create spectacular effects.

ISBN-13: 978-1-58180-753-0; ISBN-10: 1-58180-753-8; HARDCOVER, 128 PAGES, #33420

Anyone can learn these simple and fun methods for producing outstanding watercolor landscapes and flowers. *Fill Your Watercolors with Nature's Light* simplifies the painting process into a few easy-to-understand steps. Learn to use masking techniques to preserve light in your painting, pouring techniques to create atmosphere and spattering to create texture. With a chapter on fun experimental techniques, answers to frequently asked questions and a wealth of friendly and accessible instruction, this book will have you painting beautiful light-filled landscapes in no time.

ISBN-13: 978-1-58180-904-6; ISBN-10: 1-58180-904-2; PAPERBACK, 144 PAGES, #Z0341

THESE BOOKS AND OTHER FINE NORTH LIGHT TITLES ARE AVAILABLE AT YOUR LOCAL FINE ART RETAILER OR BOOKSTORE OR FROM ONLINE SUPPLIERS.

161 181
142 162 182
123 143 163 18
124 144 164 18
105 125 145 165 18
106 126 146 166 18
87 107 127 147 167 19
88 108 128 148 168 1
89 109 129 149 169
90 110 130 150 170
1 91 111 131 151 171
72 92 112 132 152 172
73 93 113 13 153 173
74 94 114 1 1 174
75 95 115 5 175
76 96 116 176
77 97 1 177
78 98 8 178
79 59 179
80 60 180

261 41 361
26 42 362
2 43 363
2 44 364
45 365
56
7
8